MW00620714

IMAGES
of America

AROUND
LIVERPOOL

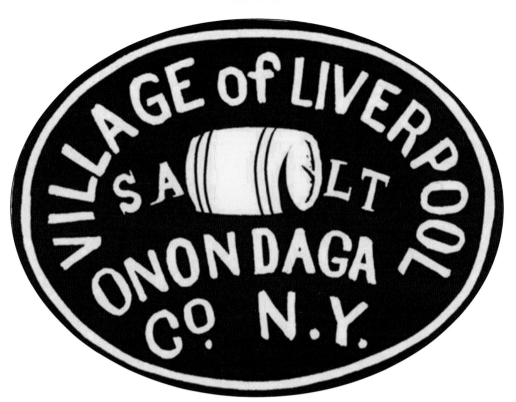

The Village of Liverpool was incorporated in 1830. On June 7, 1830, male property owners voted at the schoolhouse for six trustees to form the new village government. The new village's official seal featured a salt barrel that reflected its origins and the importance of salt—"white gold"—to the local and state economy. The seal is still in use today and has become the village logo. (Courtesy of the Village of Liverpool.)

ON THE COVER: Rudolph Lehne (1877–1856) and three other men stand near a horse-drawn wagon loaded with willow hampers in this 1926 photograph. The hampers may represent a season's worth of weaving for Lehne. Wagonloads of baskets were once a common sight in the village, as Liverpool-made baskets were shipped all over the country. Lehne's house at 109 Second Street stands in the background, today the site of the Seneca Savings Bank. (Courtesy of the Crawford Collection, Liverpool Public Library.)

IMAGES
of America

AROUND
LIVERPOOL

Dorianne Elitharp Gutierrez
and Joyce M. Mills

ARCADIA
PUBLISHING

Copyright © 2015 by Dorianne Elitharp Gutierrez and Joyce M. Mills
ISBN 978-1-4671-2352-5

Published by Arcadia Publishing
Charleston, South Carolina

Printed in the United States of America

Library of Congress Control Number: 2014956113

For all general information, please contact Arcadia Publishing:
Telephone 843-853-2070
Fax 843-853-0044
E-mail sales@arcadiapublishing.com
For customer service and orders:
Toll-Free 1-888-313-2665

Visit us on the Internet at www.arcadiapublishing.com

*To the people of small communities everywhere;
history is made of their stories.*

CONTENTS

ACKNOWLEDGMENTS

We would like to say thank you to our families, friends, and all the people who over the years have donated information, photographs, and artifacts to the Liverpool Village Museum. We are also indebted to the mayor and the Board of Trustees of the Village of Liverpool for their support of this project. The Liverpool Public Library graciously granted us the use of their photograph collections, while Jean Armour Polly and Stephanie Zwolinski provided encouragement and information. Kathryn Loomis Smith, Russ Tarby Jr., and Moyer historian Gary Smith shared additional photographs. Tim Elitharp and Joan Cregg were both our volunteer editors and main cheerleaders, and we could not have completed this project without their help.

INTRODUCTION

Liverpool, Onondaga County, New York, perches on the northeast shore of Onondaga Lake. At the time of its settlement in 1794, it was swampy and unhealthy, not the sort of location to attract settlers looking for a place to establish family farms. Due to Onondaga County's peculiar geology, however, natural brine springs bubbled up next to Onondaga Lake. The springs were noticed by the French during a brief Jesuit presence in the mid-1600s and were not forgotten when the country opened up after the American Revolution. Salt was a valuable commodity in those times, in particular demand for preserving food. John Danforth is said to be the first Liverpool salt boiler. Other entrepreneurs from New England, Jefferson County, and the Mohawk River valley soon joined him.

Further opportunities developed as the state's canal system was constructed. Liverpool was home to canal workers in the early 1820s. Many of these folks were Irish, and Liverpool was for a time called Little Ireland. The Oswego Canal opened in 1828, connecting the Erie Canal with Oswego, New York, and thus Lake Ontario. At Liverpool, the canal ran below First Street, parallel to the lakeshore and separated from the lake by a towpath. After construction, the canal provided further employment opportunities in running canal boats, repairing and building boats, supplying groceries and dry goods stores, and running hotels, boardinghouses, and taverns. Salt was no longer boiled by the single kettle, but in salt blocks, buildings that contained long lines of kettles for turning brine into fine salt on a grand scale. The salt blocks lined the canal, and Liverpool was a bustling place. In the mid-1850s, some 36 liquor permits were issued in the village, which was then (as now) only about one mile square. Temperance workers and evangelist preachers came to town regularly; their work was cut out for them. The canal was Liverpool's lifeline, a highway for information, ideas, and sin as well as goods and livelihoods.

Because of the canal system, Liverpool was also an embarkation point for westward migration as the country opened up. Many early Liverpool settlers moved on to Ohio, for example. Their traces remain in land, church, and mercantile records, but fewer in Liverpool's municipal cemetery. They stayed awhile, made some money, packed up, and moved on west.

The village was incorporated as Liverpool in 1830. The most likely explanation for the name is that the great port of Liverpool, England, was famous for shipping high-quality salt. Salt barrels stamped "Liverpool" were reputed to contain a dependable product. History does not reveal whether the name was chosen to honor the English city or as a marketing ploy.

The salt-boiling industry peaked just before and during the Civil War, when local manufacturers supplied salt to the Union army. But fuel became increasingly expensive, and after the war, new and cheaper sources of salt became available to the country. In Liverpool, salt boiling was a dead industry by the 1890s. However, solar salt manufacturing, a process that relies on evaporation to produce a coarser grade of salt, was in use along Old Liverpool Road until the last batch was produced in 1926.

The late 1840s and early 1850s saw the beginning of a wave of German immigrants to Liverpool and the surrounding town of Salina, who came seeking opportunities in the salt industry. Among the first were members of an extended family familiar with willow weaving in their home country. John Fischer, an 1852 immigrant and salt boiler, noticed wild swamp willow growing along the Euclid Road (today's Morgan Road). He wove a sewing basket and sold it to Ann Timmons (the wife of Patrick Timmons) for 50¢. About 30 interrelated families soon joined him. Basket weaving is undertaken in the winter using the fall harvest of willow, while both canal work and salt boiling tend to be summer occupations. Basket weaving offered a good supplemental income for immigrant families.

At first, the weavers made all kinds of necessary utilitarian containers, such as laundry baskets, market baskets, and sewing baskets. The demand for raw material soon exceeded the wild supply, and cultivated basket willow became a useful crop. It is a perennial shrubby plant that thrives in swampy areas where other crops may not. The roots remain in the ground and send up new branches year after year.

At the height of Liverpool's basket industry in the 1890s, willow was purchased not just from local growers, but also in great quantities from other areas along the Erie Canal, such as Lyons, Montezuma, and Port Byron. At that time, Liverpool weavers produced three-quarters of all the laundry baskets used in the United States, some 360,000 baskets annually from a village the population of which has never been much over 2,800 people. At the same time, the basket makers became the true "settlers" of Liverpool. Immigrant families became, in the space of one or two generations, the pillars of local churches, government, schools, and other community organizations.

Despite the production volume, basket weaving was largely undertaken as a family cottage industry in small backyard shops. After willow was harvested, it was passed through a commercial steamer to soften the bark and kill insects and then delivered to individual weavers. Children typically ran each wand through a special tool to crack the bark and then stripped it by hand. The weavers would then soak it in batches as needed to make it pliable for weaving. The women often made the basket bottoms, while the men wove the sides and finished the rims. Very good weavers could make up to 25 baskets a day. The bark strippings would be piled around the building foundations as insulation and later removed and burned in the spring. It was said that Liverpool residents could be identified by the acrid smell of willow strippings smoke that permeated their clothing.

The basket industry began to die out in the 1920s under competition from foreign imports and as better transportation and larger industries opened up other ways to make a living in the area. Liverpool at that time began its transformation into the commuter community that it is today. A few willow manufacturers, particularly those who made furniture and other "fancy work," persisted in the 1960s and early 1970s. None are left today.

Before World War II, increasingly prosperous industrial workers characterized 20th-century Liverpool's emergence from the Great Depression. After the war, the growing presence of the General Electric Company on an industrial campus near Liverpool brought an influx of engineers and other highly educated workers to the rapidly growing suburbs in an area now called greater Liverpool. The working-class character of Liverpool village, like many villages in the country that were founded on local industries, is now a thing of the past. However, local history remains alive and is a cohesive force in the community.

One

WORTH OUR SALT

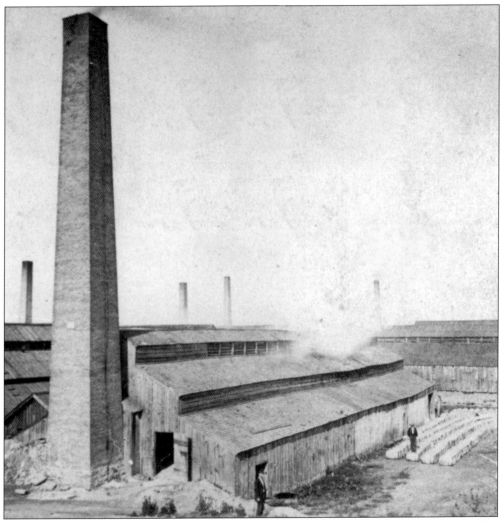

It is hard to imagine the scene around Onondaga Lake on the Liverpool, Syracuse, and Geddes shores when salt was king. Local salt was produced from natural brine springs in the area. This stereopticon slide is a view of a fine salt boiling block, which is a building holding blocks of kettles, with barrels lined up outside. The local salt industry was famous, and souvenir slides, postcards, prints, and pamphlets can be found in today's collectible stores and online. (Courtesy of the Schuelke Collection, Liverpool Public Library.)

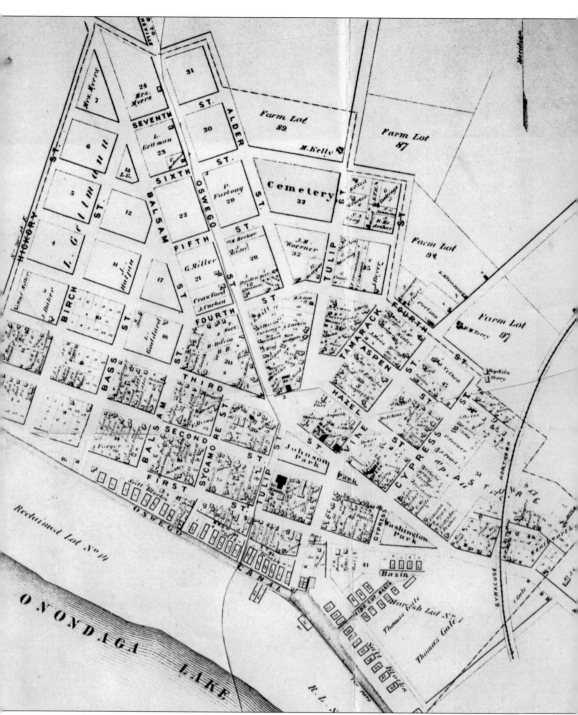

From a few log cabins in 1800, Liverpool grew to a prosperous village about one mile square. The population was about 2,000 at the time of this 1874 *Sweet's Atlas* map. The map shows some of the unique features of the village, including the Oswego Canal and towpath near the bottom. The numbered rectangles on the banks of the canal are salt blocks, the buildings where brine was boiled to make fine salt. (Courtesy of Liverpool Village Museum.)

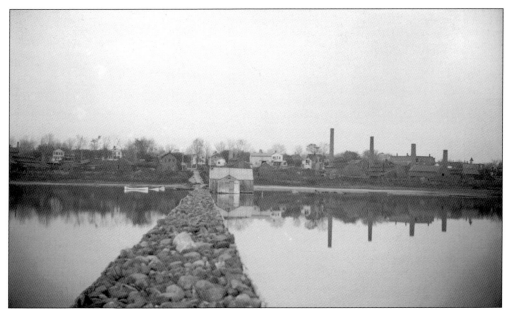

The Onondaga Lake shore in 19th-century Liverpool was an industrial area, in contrast to today's recreational park. This c. 1890 view from an old stone pier in the lake looks up toward the foot of Sycamore Street. Salt boiling block chimneys are at the right, and behind them, one can see the backs of buildings on Liverpool's First Street. The salt boiling industry was in its final decline when this picture was taken, and the blocks were deteriorating. (Courtesy of the Crawford Collection, Liverpool Public Library.)

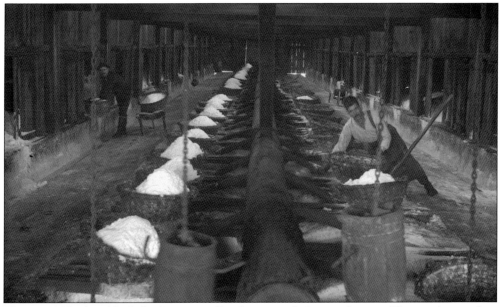

This c. 1880 boiling block displays rows of kettles suspended over a furnace. The wooden pipeline running down the center of the block brought brine to the kettles. George Dow (1856–1909) stands by one of the built-in drying bins while Jacob Frank (1859–1925) is leaning over a kettle. The weighted pulleys were used to open or close the fire doors in the furnaces located below the block. (Courtesy of the Crawford Collection, Liverpool Public Library.)

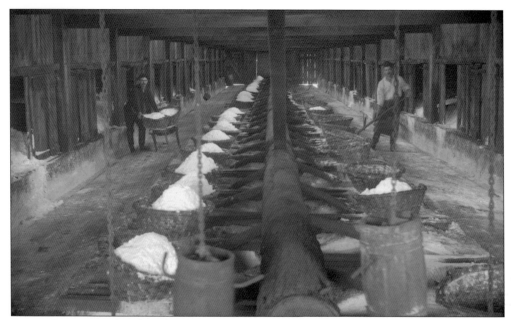

George Dow is posed with a wheelbarrow, preparing to dump baskets of salt into the drying bins built into the side of the boiling block. Jacob Frank is using a long-handled scoop to take salt out of the kettle and place it in the baskets to drain. Since there is no visible steam, the fires are out and the kettles are cold. (Courtesy of the Crawford Collection, Liverpool Public Library.)

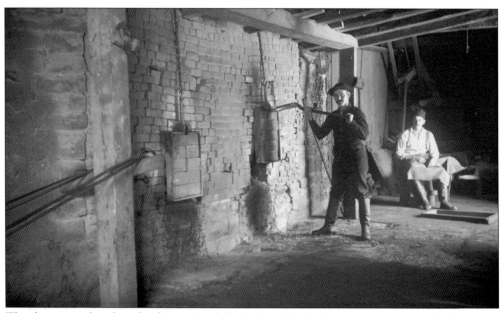

The doors are closed in the firing pit of this boiling block. Firing pits were attached to their chimney by parallel flues, which ran under the kettles. George Dow has the shovel, and Jacob Frank is seated. Wood, and later coal, was used to keep the kettles boiling. (Courtesy of the Crawford Collection, Liverpool Public Library.)

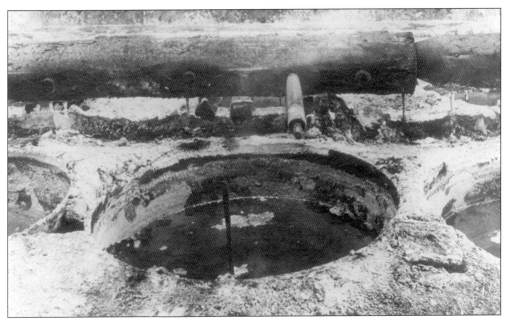

This photograph shows a single salt kettle and the log pipeline that carried the brine to each kettle. Hollow logs were used to pipe the brine to the salt blocks and to the kettles because brine would have corroded metal. Even the spigot in the pipeline is made of wood. Note the salt "icicles" that have formed at a leak in the pipeline. (Courtesy of the Schuelke Collection, Liverpool Public Library.)

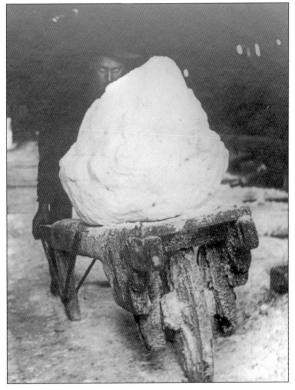

Salt boiling was hard work for all except the salt block owners and merchants, but it guaranteed a living for many years in 19th-century Liverpool, drawing Irish and German immigrants throughout much of the century. This unidentified workman is pushing a wheelbarrow loaded with a large lump of fine salt. The lump of salt is shaped like a split-ash draining basket and was probably too wet when placed in the basket. When it dried, it solidified in the shape of the basket. (Courtesy of the Schuelke Collection, Liverpool Public Library.)

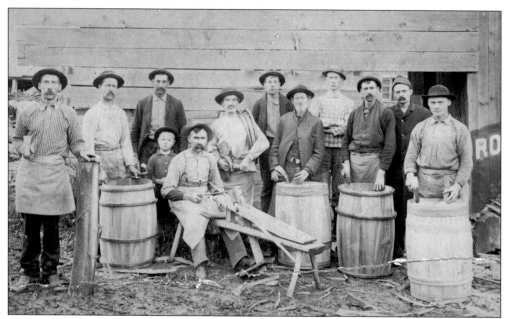

Liverpool's salt industry created other economic opportunities. Coopers made barrels for storing and shipping salt and other commodities. John Gridley (1855–1923) is the third man from the right (with barrel). The others are not identified. Note the young boy among the workers. In the days before child labor laws, children often worked alongside their elders. (Courtesy of Liverpool Village Museum.)

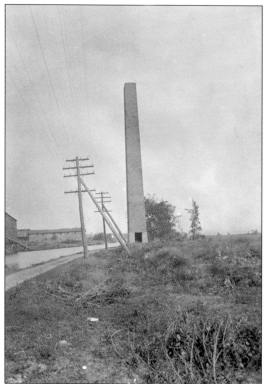

This lone chimney was all that was left of the Jaqueth salt block around 1920. The picture is taken from the towpath of the Oswego Canal shown on the left. Other salt boiling blocks remain on the shore to the left of the canal. The chimney was originally attached to Salt Block No. 56, built by Stephen Van Alstine in 1856. Today, it remains as the chimney for Onondaga County's Salt Museum. (Courtesy of the Schuelke Collection, Liverpool Public Library.)

While some Liverpool salt manufacturers profited from the war, other citizens went off to fight. Sixty Civil War veterans are buried in the small village cemetery. Thomas D. Wentworth, the son of two of Liverpool's first settlers, was a carriage driver when he mustered in at Buffalo in August 1862. His papers described him as 24 years old, 5 feet, 8 inches tall, with sallow complexion, blue eyes, and brown hair. He was killed in Virginia and is buried with his family in the Liverpool Cemetery. (Courtesy of Liverpool Village Museum.)

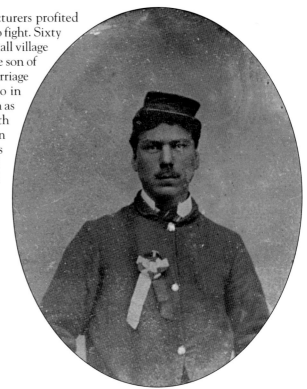

Dr. John R. Young (d. 1915) stands in front of his home at 419 First Street. Young fought in 11 Civil War battles before being wounded at the Second Battle of Bull Run. He was shot in the head, the shoulder, and the left leg. Two balls went through his left arm, and he suffered a fractured foot. After the war, Young attended Hahnemann College, graduating with a degree in homeopathic medicine. (Courtesy of Liverpool Village Museum.)

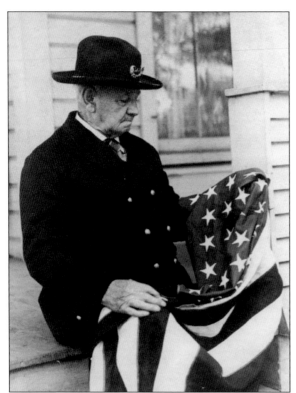

Charles Elijah Edwards (1846–1935) was the last surviving Civil War veteran in Liverpool. He served with the 111th New York Volunteers, Company E, as a private and participated in the battles of Bull Run and Gettysburg. Edwards was a local builder who also had a political career, serving as county treasurer (1924–1927) and, according to his June 13, 1935, obituary, "filled almost every position in the gift of the people in the village of Liverpool, as well as in the town." (Courtesy of Liverpool Village Museum.)

Charles Edwards built his home at 601 Second Street; the house, with its wraparound porches enclosed, still stands. Charles moved to Liverpool in 1865, and he and his wife, Julia Schoolcraft, were married in the house in 1872. Charles Edwards evidently did well after the war; the original house was built in the popular Italianate style. (Courtesy of the Crawford Collection, Liverpool Public Library.)

Lucius Gleason (1819–1893), the eldest of 11 children, was widely admired as a self-made man. He personified the American ideal, a man who, despite humble beginnings, succeeded through ambition, entrepreneurial spirit, and grit. Lucius began his career as a clerk and then bought a grocery with his father. He expanded his enterprises from the store to salt to shipping to real estate, and at his death was president of the Third National Bank of Syracuse. (Courtesy of Liverpool Village Museum.)

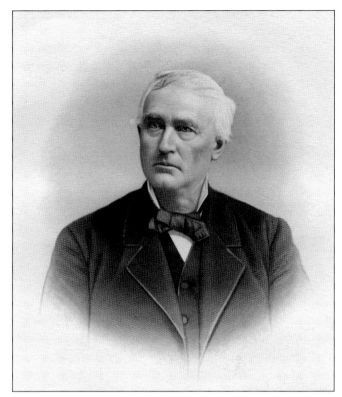

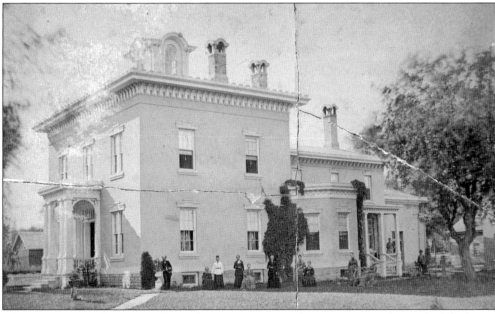

This c. 1885 print shows the Gleason house at 314 Second Street. Lucius Gleason had the house constructed on the site of his parents' homestead in 1858. The late 1850s and early 1860s were very prosperous years for salt manufacturers; the Lucius Gleason house is one of the first Italianate "houses that salt built." The house is now listed in the National and State Registers of Historic Places. (Courtesy of Liverpool Village Museum.)

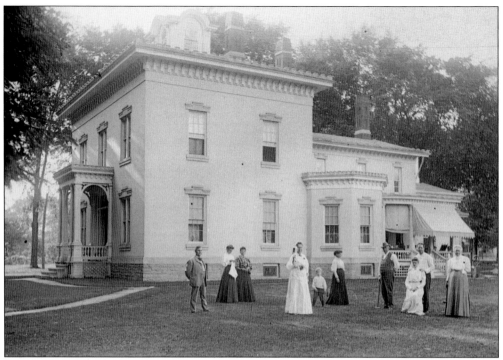

In 1901, friends and relatives of the Gleason and Lacy families gather to play croquet in the side yard. This picture shows some of the house's architectural details that are now gone. The awning at the back right shelters a breakfast porch that was accessible from the pantry of the house. The breakfast porch and the dentil molding around the edge of the roof have not survived. However, the overall appearance of the house is much the same. (Courtesy of the Schuelke Collection, Liverpool Public Library.)

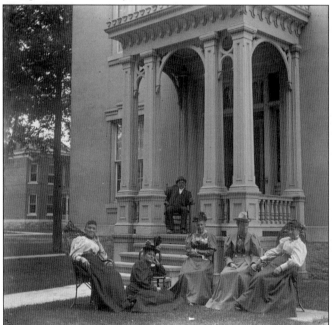

Henry Lacy (1845–1926), nephew of Lucius Gleason, sits on the front porch of the Gleason house. Henry's mother, Azubah Gleason Lacy, is seated at left. Next is a daughter of Henry and then his wife, Kate. Kate's sister Nell is second from the right; she married Orson Gleason (Lucius's brother). On the far right is Lucius's sister Martha, who lived with Orson in the Gleason house. Orson Gleason died shortly after his marriage to Nell amid rumors of poisoning by Nell, and Nell and Martha Gleason became uneasy roommates. (Courtesy of the Crawford Collection, Liverpool Public Library.)

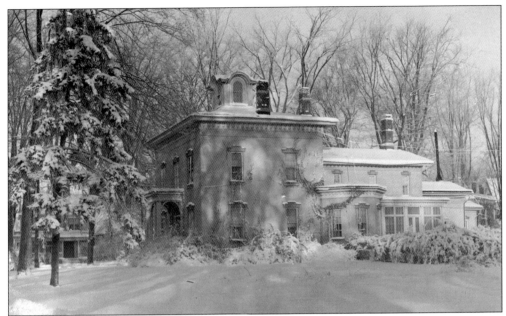

In the winter of 1948, photographer Theodore Schuelke took this beautiful image of Lucius Gleason's former house. The Village of Liverpool had seized the property for back taxes in 1938, and the house had been the Liverpool Village Hall for 10 years at the time of the photograph. Schuelke called it "a study of the old Lacy Homestead on Second Street, following a recent snowstorm." (Courtesy of the Schuelke Collection, Liverpool Public Library.)

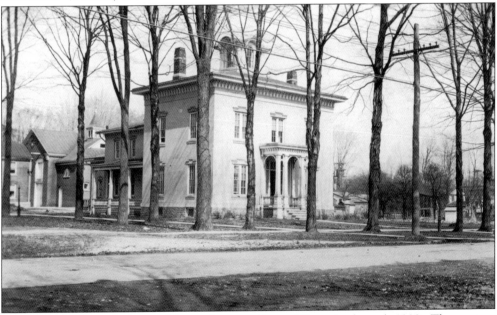

This postcard shows the Lucius Gleason house on Second Street in the early 1900s. The carriage house is visible behind the house at the left. When the Village of Liverpool assumed ownership of the property in 1938, the carriage house became the fire hall. Now, after a 2000 renovation, the carriage house is the Liverpool Village Hall, housing also the police department and justice court. (Courtesy of the Schuelke Collection, Liverpool Public Library.)

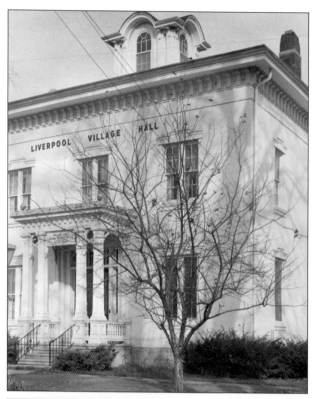

The Gleason house served as the Liverpool Village Hall from 1938 to 1988 and was the home of municipal offices, the police department, village court, the American Legion, the public library, and various other public and community functions during this period. The side lawn, acquired by Lucius Gleason in 1846, was the site of Memorial Day celebrations and other public events. Today, the building houses the Liverpool Village Museum, the Greater Liverpool Chamber of Commerce, and various small businesses as tenants of the Gleason Center. (Courtesy of Liverpool Village Museum.)

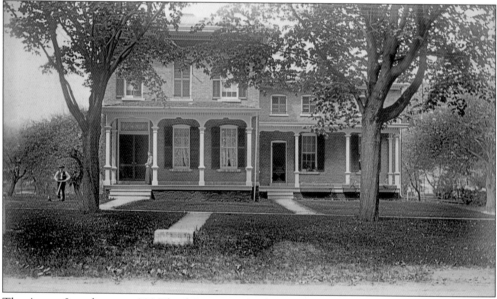

The Anson Lacy home at 200 Third Street was built around 1865, not far from Lucius Gleason's "house that salt built" at 314 Second Street. Lacy (1812–1879) married Azubah Gleason (1822–1910), Lucius's younger sister, and was involved in the Third National Bank with his brother-in-law. When Lucius died in 1893, Anson and Azubah Lacy's son Henry (1845–1926) was his executor and gained control of the bank and other assets, to the chagrin of other relatives. This photograph was taken around 1900. (Courtesy of the Schuelke Collection, Liverpool Public Library.)

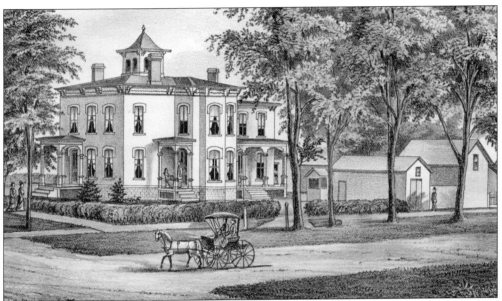

Clark's 1878 *History of Onondaga County* presents this idyllic picture of the John Paddock residence on the corner of Second and Tulip Streets in the village. Paddock (1805–1880) moved to Liverpool in 1826 and started out in the salt business. He later became a successful merchant, able to renovate and rebuild the old homestead in the popular Italianate style. Paddock was elected a trustee of the new Village of Liverpool in 1830 and served as the village president in 1833 and 1836 and as supervisor of the Town of Salina in 1859. (Courtesy of Liverpool Village Museum.)

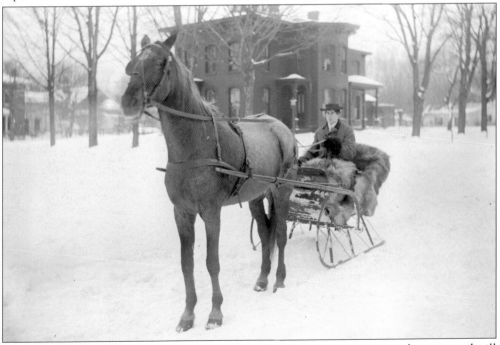

This unidentified driver has a fur throw over his shoulders, is sitting on another one, and still looks cold. The Paddock house is seen in the background. (Courtesy of the Schuelke Collection, Liverpool Public Library.)

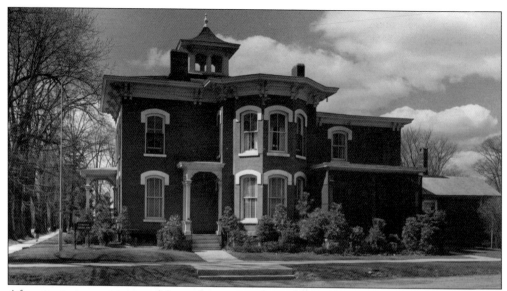

After serving as a private residence for many years, John Paddock's house became the Tucker Funeral Home and then the Maurer Funeral Home. By 1949, the date of this photograph, Maurer's sign is visible in the front yard. The funeral-home business has stayed in the Maurer family, and the house still stands today; although it has been much altered to accommodate the business. The cupola remains on the roof, and from the Second Street side (on the left in this photograph), one can get an idea of how the house looked in John Paddock's day. (Courtesy of the Schuelke Collection, Liverpool Public Library.)

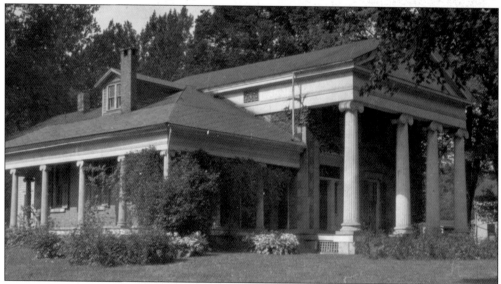

The Jonathan Hicks house at the corner of Vine and Aspen Streets was constructed with cobblestones and salt wealth in 1854. Looking grand in this 1930 photograph, it still stands today. Most Greek Revival homes in Liverpool were rather modest, but Hick's house features a full-height, full-pediment portico; cut-stone lintels and sills, with irregularly spaced fluted Ionic columns that flank its doorway; and the colonnade around the hip-roofed side wing. Hicks also had built the Cobblestone Hotel at the corner of First and Tulip Streets in 1839, next to his more modest 1830 home. (Courtesy of the Schuelke Collection, Liverpool Public Library.)

The George Bassett home at 215 Sycamore Street is another Italianate "house that salt built." Not quite as imposing as the 1858 Gleason house on the diagonally opposite corner, Bassett's house featured the same fashionable (and expensive) kiln-fired flashed-glass windows around the doorway. Like most of his well-to-do contemporaries, Bassett (1817–1909) was involved in several enterprises, notably cigar manufacturing using locally grown tobacco. (Courtesy of the Crawford Collection, Liverpool Public Library.)

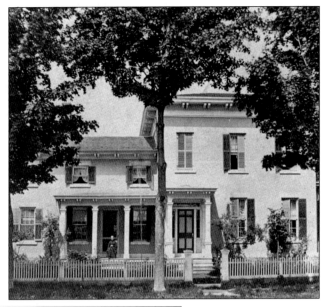

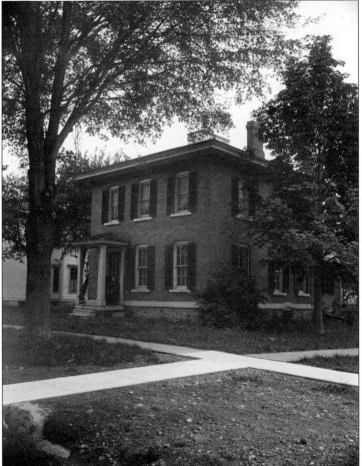

The Peter Moschell (1796–1875) house at 419 Second Street stands in the area of oldest Liverpool settlement, the site of several log cabins clustered around a natural spring. A tavern occupied this site in the early 1800s, but by the 1840s, the tavern had become dilapidated ruins. Children ran past the site, which was reputed to be haunted. The Moschell house, constructed around 1860, is another "house that salt built" in the square Italianate style. (Courtesy of the Crawford Collection, Liverpool Public Library.)

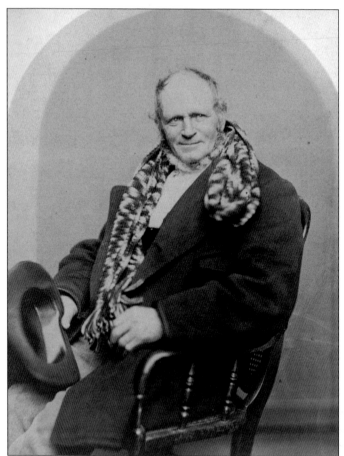

Fine salt was produced by boiling, but fuel became expensive after the Civil War. Solar salt used evaporation to produce a coarser salt. Thomas Gale (1814–1888), an English immigrant, was the king of the large solar salt yards that stretched along Old Liverpool Road, an area still called Galeville. Despite his wealth, this portrait shows a man with a kind smile, a twinkle in his eye, and a homemade scarf. (Courtesy of the Schuelke Collection, Liverpool Public Library.)

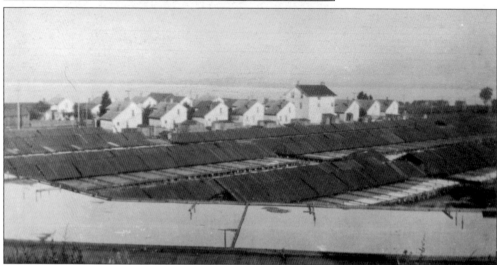

Thomas Gale provided housing for the workers employed in his solar saltworks. Here, workers' houses are clustered along Old Liverpool Road near the two-story Gale salt office building just to the right of center. The solar salt yards and apron areas are in the foreground, and Onondaga Lake is seen in the far background. (Courtesy of the Schuelke Collection, Liverpool Public Library.)

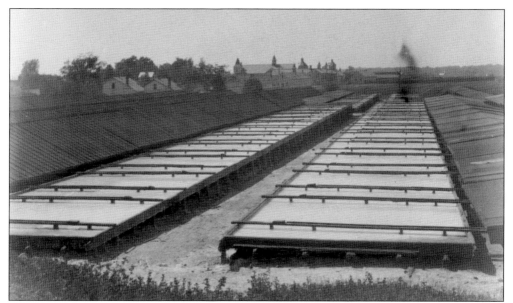

In solar salt manufacturing, brine is pumped into the low flat vats shown in this 1925 photograph. The covers on the vats are pulled back to expose the brine to the sun for evaporation. As the water evaporates, coarse salt crystals are left for harvesting and packing. These are some of the Gale salt vats near Old Liverpool Road, which runs along the trees at left. (Courtesy of the Schuelke Collection, Liverpool Public Library.)

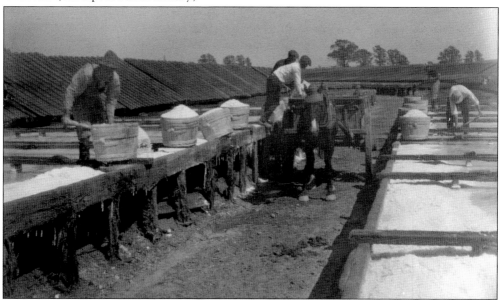

Workers in the Gale solar salt yards near Old Liverpool Road are harvesting coarse salt. Three men are shoveling salt into wooden draining tubs while two other workers dump drained tubs into a waiting horse-drawn dump cart. The salt icicles, hanging off the bottom of some of the salt vats, recall a now lost folk art. People placed objects under the brine leaks to coat them with the dripping brine. As the water evaporated, the objects were coated with salt crystals, and small glittering sculptures were the result. (Courtesy of the Schuelke Collection, Liverpool Public Library.)

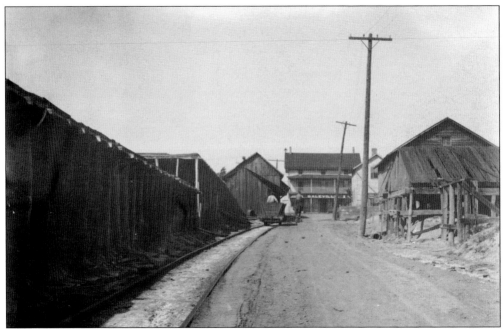

A load of coarse solar salt moves down the tracks toward a storehouse. The Gale solar salt office on Old Liverpool Road, later the Galeville Grocery, is visible in the center of the picture. Deep and lime rooms, where impurities are allowed to settle out of the brine, are on the left. (Courtesy of the Schuelke Collection, Liverpool Public Library.)

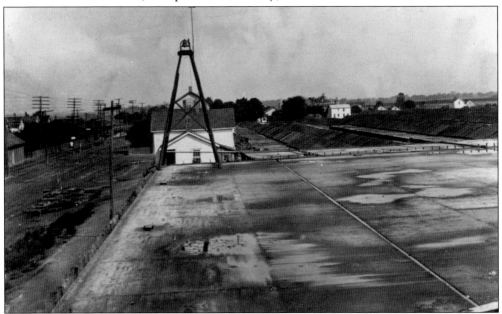

The alarm bell mounted on this tower was located at the Gale solar salt yards on Old Liverpool Road. In case of rain, the bell summoned workers and their families to pull the covers over the vats to protect the drying salt. The trolley tracks on the left date this photograph to the early 20th century, near the end of the salt era. (Courtesy of the Schuelke Collection, Liverpool Public Library.)

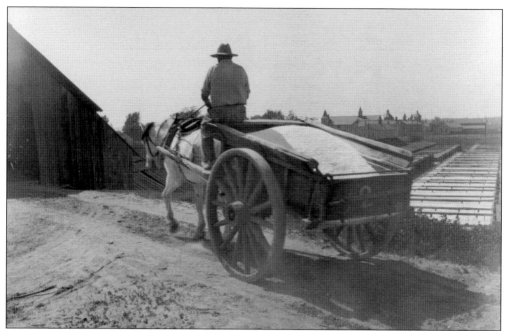

A Gale salt worker drives a horse-drawn dump cart filled with salt up the road toward the storehouse. Solar salt vats and covers can be seen in the background. This photograph was taken in 1925, the year before the last solar salt was produced at the Gale salt yards. (Courtesy of the Schuelke Collection, Liverpool Public Library.)

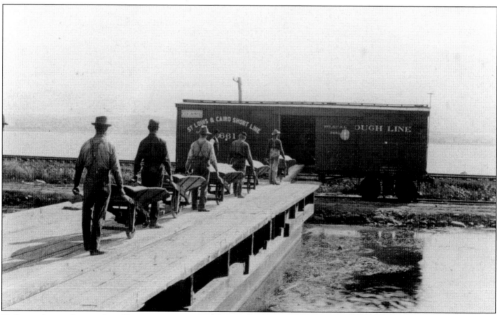

Solar salt workers wheelbarrow coarse salt into a St. Louis & Cairo Short Line boxcar. They are travelling on a swing bridge over the Oswego Canal. While the Oswego Canal was the primary means of shipping the fine salt produced by boiling brine, the railroad took its place in later years as the means to ship solar salt. Onondaga Lake is in the background. (Courtesy of the Schuelke Collection, Liverpool Public Library.)

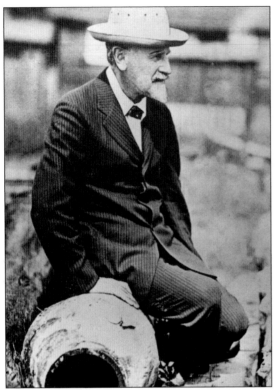

Thomas K. Gale (1858–1938), son of Thomas Gale—the solar salt king, had the sad distinction of being the last Liverpool salt manufacturer. His last batch of solar salt was produced in August 1926, and after some legal wrangling, his land bordering the Oswego Canal was sold to Onondaga County. When the canal was filled in and Onondaga Lake Parkway was created in 1933, a decorative stone enclosure was built around the Gale salt spring to commemorate the Gales and the solar salt industry. (Courtesy of the Schuelke Collection, Liverpool Public Library.)

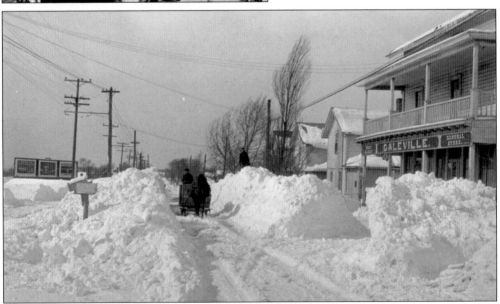

Winter lingered in March 1932, as it does so frequently in Central New York. On Old Liverpool Road, a horse-drawn box sled approaches the photographer through towering snow banks in Galeville. The Galeville General Store, which formerly housed Thomas Gale's salt office, is on the right. The houses on the right, probably originally some of Gale's worker housing, are gone today while the left side of the road is densely built up. The Galeville Grocery was torn down in February 2011. (Courtesy of the Schuelke Collection, Liverpool Public Library.)

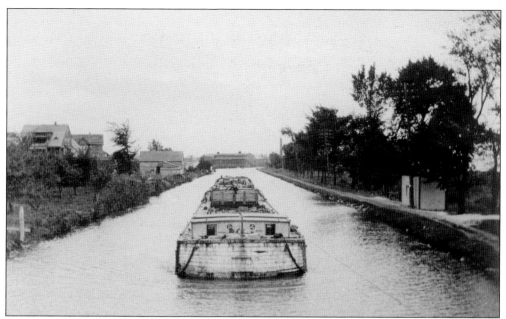

This photograph was taken looking south down the Oswego Canal from the center of the Sycamore Street Bridge. The canal towpath is visible on the right side, and Onondaga Lake is beyond the trees. The backs of First Street houses and canal-front outbuildings are on the left. Images like these show how connected canal and village life were, a condition that is easy to state but difficult to imagine today. (Courtesy of the Schuelke Collection, Liverpool Public Library.)

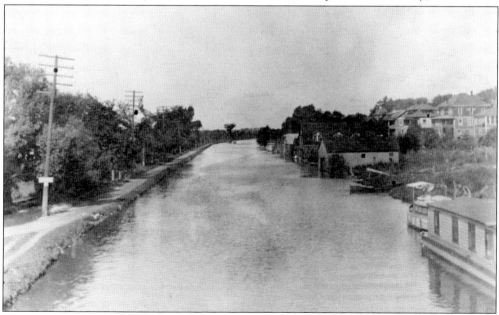

This 1910 view of the Oswego Canal looks north from the center of the Sycamore Street Bridge. Houses and boathouses in the 600 block of First Street are on the right. Among these was the boat repair business of Charles Cole (1877–1936) at 607 First Street. Cole designed and built boats and engines for his own business as well as for Barber Bros. in nearby Syracuse. (Courtesy of the Schuelke Collection, Liverpool Public Library.)

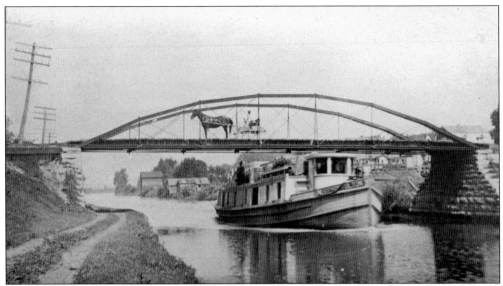

This image of the Oswego Canal at the Sycamore Street Bridge was taken looking northwest along the canal from the towpath on the left. The *City of Fulton* steams beneath the bridge while Herman Fairchild (1847–1940) in his horse-drawn buggy is stopped on the bridge. It would not be long before Fairchild would be driving a horseless carriage. (Courtesy of the Schuelke Collection, Liverpool Public Library.)

Wanted!

1000 WIVES

in Liverpool and vicinity, to send their Husbands to Timmon's Grocery for all their provisions.

All Fruits and Vegatables in Their Season.

☞ Store on the Steamboat Wharf at the foot of Sycamore St. 1tf

Whether Nicholas Timmons or the editor of the Liverpool *Lakeside Press* had the inspiration, this eye-catching advertisement appeared in the newspaper on October 26, 1871. Timmons's store "on the Steamboat Wharf at the foot of Sycamore St." would have fronted the Oswego Canal, and business must have been brisk. Running a canal store was a popular venture in 19th-century Liverpool, and along with operating taverns or a boardinghouse, it was a profitable way to make a living in the busy village. (Courtesy of Liverpool Village Museum.)

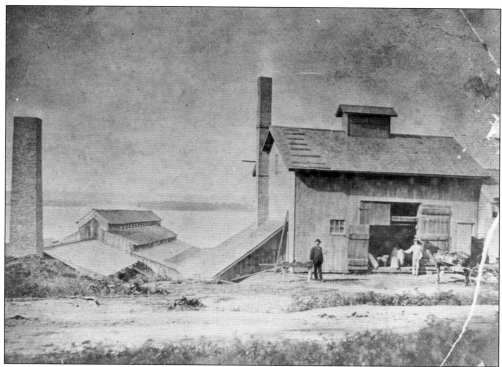

Amos Herbert Crawford (1848–1931) was a Liverpool entrepreneur and journalist who tried his hand at many occupations. This image shows Crawford's gristmill at the foot of the west side of Sycamore Street in Liverpool, conveniently located to receive and ship materials. Note the salt block on the left, bordering the Oswego Canal, and Onondaga Lake in the background. (Courtesy of the Schuelke Collection, Liverpool Public Library.)

In this c. 1895 photograph are Hart family members, posed by their house at 511 Third Street. Although the Harts were not wealthy, they made a good living shipping goods on the canal. Their early-19th-century frame house has "modern" Victorian detail. Liverpool was a muddy place in the spring, but it was prosperous enough by the 1890s to feature plank sidewalks on several streets. The Hart house still stands today. (Courtesy of the Crawford Collection, Liverpool Public Library.)

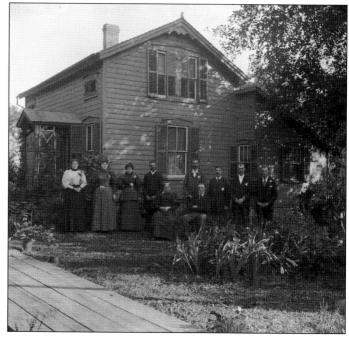

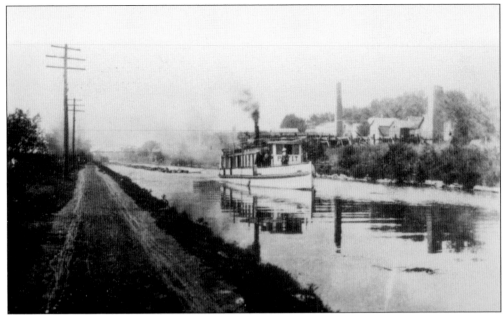

Dragging a load, the steamboat *Petit of Syracuse* is seen coming down the Oswego Canal. The *Petit* carried freight daily between Fulton and Syracuse. The chimneys of Liverpool salt blocks and other buildings are on the right in this late-19th-century photograph. Telegraph wires are strung along the towpath. Like the steamboat, they signal more modern times near the end of both the salt and canal eras. (Courtesy of the Schuelke Collection, Liverpool Public Library.)

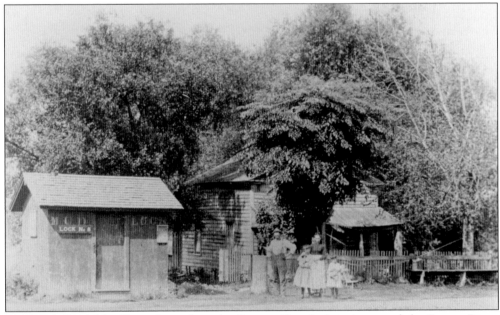

Mud Lock (Lock No. 5) was located on the Oswego Canal where it entered the Seneca River. The *Genealogy of the Greene Family* by Charles Greene states that Job Greene and family moved to Mud Lock in 1863, where they ran the grocery stores and farmed adjacent land. It goes on to say, "Here my grandfather carried on a brisk business in groceries and meats with the canal boats." (Courtesy of the Schuelke Collection, Liverpool Public Library.)

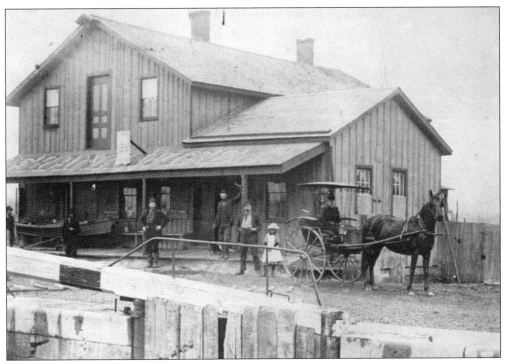

Patrons and passersby at Frank Wise's Mud Lock Tavern & Hotel include, from left to right, Jim Cronk, of Liverpool; Billy Rose, who had a shack at Mud Lock; Jess Kinney, of Liverpool; Frank Wise with his dog Jerry; Sachs Zieger; Agnes Wise; and Mrs. O.W. Oberlander in Dr. Oberlander's road cart. The tavern was demolished in 1932 when the Onondaga County Emergency Work Bureau restored the lock as a historic landmark. (Courtesy of the Crawford Collection, Liverpool Public Library.)

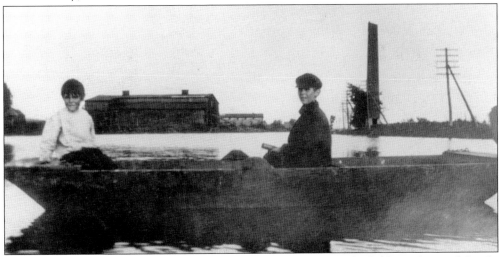

Joseph L. Wentworth (1904–1985) and his brother Ken (1917–1996), children of a canal family, sit in a rowboat in the drydock basin of the Oswego Canal. The Timmons Salt Block and the Jaqueth chimney are in background. The canal side cut and drydock basin were located behind lower First Street. Boatbuilding and repair businesses were located at this site, called the wide waters area. (Courtesy of the Schuelke Collection, Liverpool Public Library.)

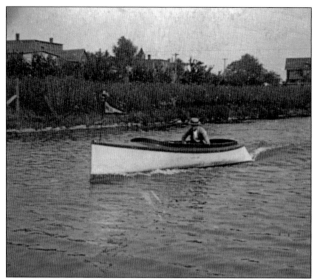

Frank Alvord (1875–1951) cruises the Oswego Canal in a motorboat. Although the canal's glory days had passed, it was not filled in until 1933 during an Onondaga County public works program, which also created Onondaga Lake Parkway and the Onondaga Lake Park. The brick building at the left in the background is likely the one still standing at the southwest corner of First and Tulip Streets in the village, and Frank Alvord is passing just below Brow Street. (Courtesy of the Crawford Collection, Liverpool Public Library.)

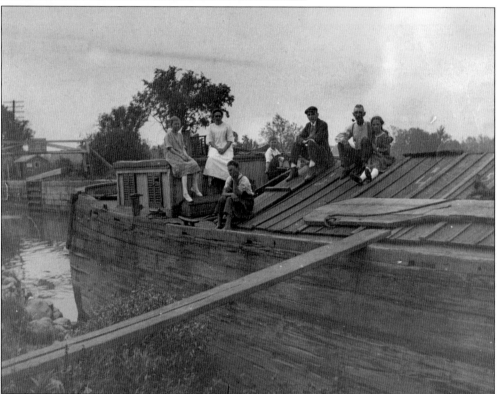

Entire families made their living on the canal. Women served as cooks while the men worked as mule tenders and pilots. The Wentworths of First Street were descendants of some of the first settlers in Liverpool. Four generations made their living on the canal. This c. 1913 image shows the Wentworth family and friends on the barge *Wyker* at Mud Lock during the canal's last days. From left to right, they are Thelma Eckert, Laura Wentworth, Wallace Wentworth, Thomas Wentworth, George Nowack, James Wentworth, and Arda Wentworth. (Courtesy of the Schuelke Collection, Liverpool Public Library.)

Two

WEAVING THE STORY

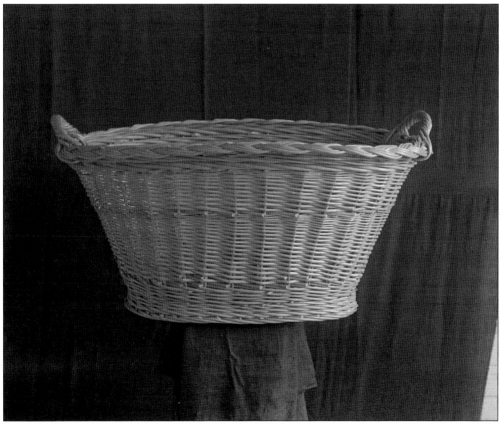

Positioned like a sculpture, a handmade Liverpool laundry basket exemplifies both beauty and utility. There were no written plans or directions. Liverpool weavers learned their craft by copying each other. Most probably regarded the craft as a livelihood—not an art—and did not sign their work. (Courtesy of the Crawford Collection, Liverpool Public Library.)

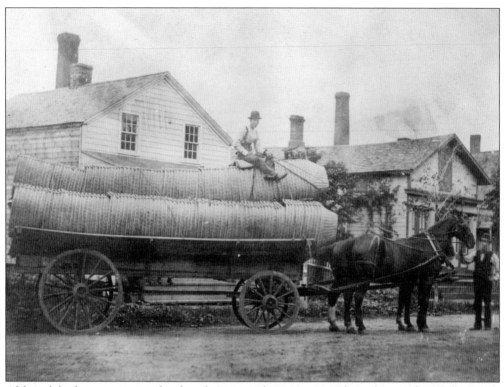

Although basket weaving was hard work, Liverpool weavers turned out thousands and thousands of baskets annually; estimates of the volume in the 1890s, at the height of the basket industry, range from 30,000 to 50,000 dozen baskets a year. Here is one wagonload of laundry baskets, ready for shipment by rail or canal to a wholesaler. George Fischer (1852–1935), son of Liverpool's first basket maker, is sitting on top of the load. (Courtesy of Liverpool Village Museum.)

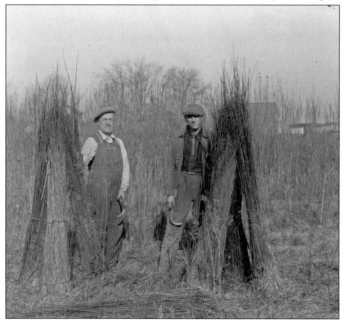

Two men are harvesting basket willow with typical curved knives sometime around 1910. Basket willow proved to be the perfect crop for the swampy ground in and around Liverpool that was not good for growing other crops. As the basket industry grew, the demand exceeded local supply, and basket willow became a profitable crop for local communities. Basket willow still grows wild around Liverpool. (Courtesy of the Crawford Collection, Liverpool Public Library.)

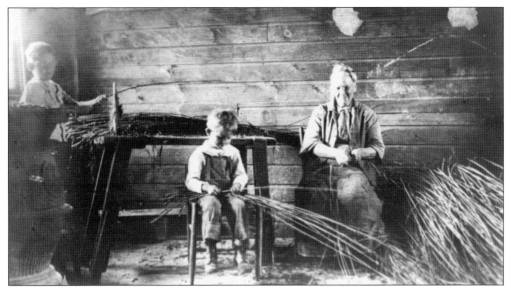

Willow processing in Liverpool typically involved the whole family. Mrs. John Renk (Magdelene) of 623 First Street and her two grandsons are stripping the bark off willow branches in the family workshop. The boy on the left is pulling a willow branch through a special tool sometimes called a "cracker" that loosens the bark. Magdelene and her other grandson are peeling the loosened bark off by hand, and the results of their work are visible on the right. (Courtesy of the Schuelke Collection, Liverpool Public Library.)

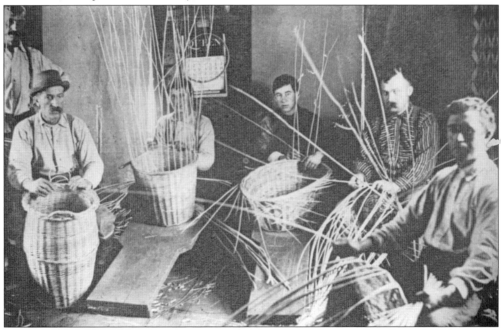

John Fischer (1811–1897), a German immigrant who came to Liverpool in the mid-1850s to work at salt boiling, is credited with starting Liverpool's willow basket industry. Only one generation later, five men and Fischer's son George (1852–1935) sit in George's basket shop weaving baskets. Pictured from left to right are Will Traister, George Fischer, R. Daucher, Jake Auftring, and the Barnes brothers. (Courtesy of the Crawford Collection, Liverpool Public Library.)

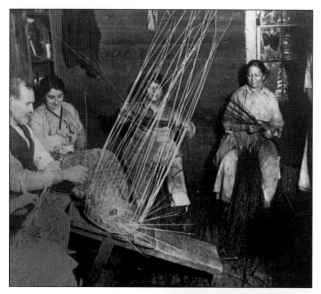

In Naumann's basket shop at 105 Pearl Street, around 1910, a basket-making family works as an assembly line. At the far left foreground, Neta Naumann works on a basket bottom. Henry sits at the workbench, weaving the sides of a basket. Next to him, Kitty Naumann trims excess willow from a finished laundry basket. Their neighbor Mary Schreiner and George Fischer's wife, Bertha, are stripping willow, while the Fischers' daughter Bertha M. pulls a willow wand through a cracker to loosen the bark. (Courtesy of the Crawford Collection, Liverpool Public Library.)

Paul Gerhardt (1901–1944) works on a willow basket at the Raupauch Furniture Company. Charles Raupach (1860–1931), known as the artist of the industry, was one of only a few weavers who employed others in their operation. Raupach emigrated from Germany in 1881, bringing his craft with him. He manufactured a wide variety of furniture and decorative objects as well as baskets, selling much of his output to wholesaler L. Thurwachter whose warehouse was at 208 First Street. An unfinished willow chair lies in the foreground. (Courtesy of the Crawford Collection, Liverpool Public Library.)

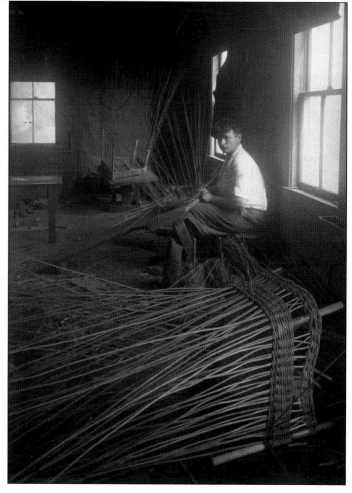

Charles Pease (1839–1920) poses in his workshop at 511 Second Street as he works on an oval laundry basket. His workbench is a typical slanted one, certainly homemade. The weaver would pin the basket bottom to the bench with an awl so that the basket could be easily turned as the sides were woven. Often the bench also had a tray or slots for tools. (Courtesy of the Schuelke Collection, Liverpool Public Library.)

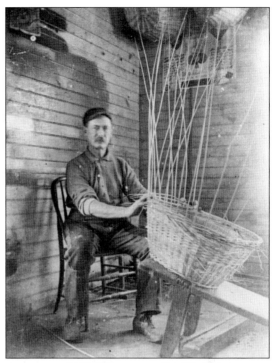

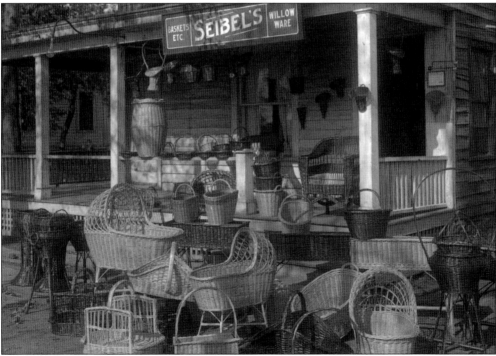

Some of the many willow products that were offered for sale in Liverpool are displayed at Jacob Seibel's (1880–1947) house and business at 314 Oswego Street, around 1930. Willowware was often displayed on front porches and in yards to attract business from people driving through the village. (Courtesy of the Crawford Collection, Liverpool Public Library.)

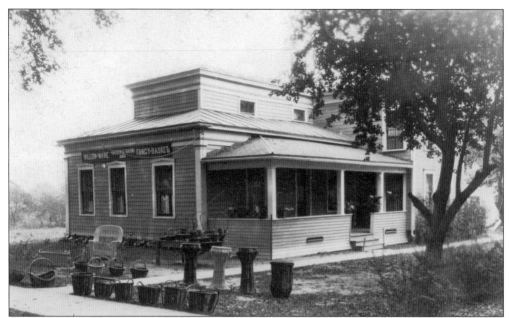

Valentine Bahn (1837–1917) was the maker of the baskets and fancy willowware displayed on the lawn of his home at 808 Oswego Street. This house dates to the mid-1830s and is the only one of this "ink bottle" type in the village. (Courtesy of Liverpool Village Museum.)

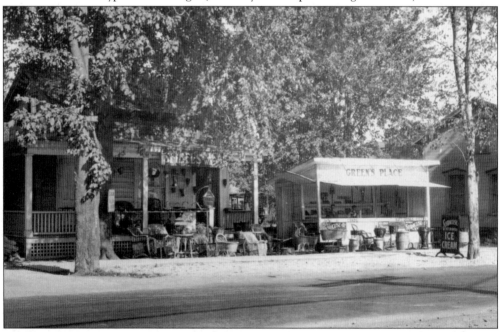

Some weavers sold their goods strictly to wholesale dealers, but others sold to retail customers from houses and stands along the side of the road. This 1924 photograph of the corner of Willow and Oswego Streets in the village demonstrates that Liverpool weavers had moved well beyond laundry and market baskets. Tables, a birdcage, a bassinet, chairs, hampers, and fern baskets are on display along with souvenirs and Syracuse Ice Cream to attract passing traffic. (Courtesy of the Schuelke Collection, Liverpool Public Library.)

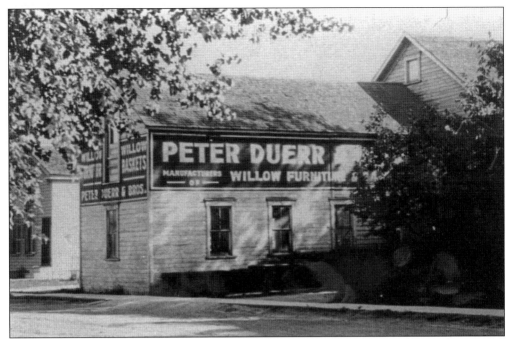

"Liverpool's Largest Willow Factory," as advertised by its owner, belonged to Peter Duerr. His factory and showroom were located at 110 Willow Street. Duerr employed up to 23 people at once, unusual in the village were most weavers had family operations. Duerr, who came from Germany in 1879 as a child of four, created a business that shipped willowware as far south as Florida and to the West Coast. (Courtesy of the Crawford Collection, Liverpool Public Library.)

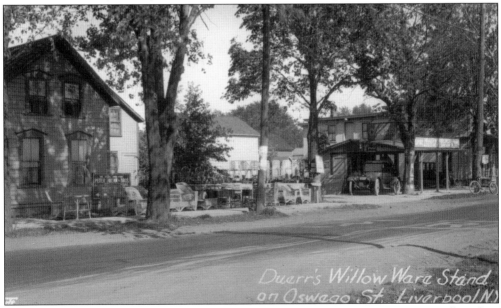

In 1924, a partially hidden sign invites passing traffic to visit Peter Duerr & Bros. willow shop around the corner on the aptly named Willow Street. Signs on the far right, above and next to the shop advertise Coca-Cola, coneys (a type of white hot dog), and Miller and Schreiner's ice cream stand. (Courtesy of the Schuelke Collection, Liverpool Public Library.)

Duerr's c. 1920 willow furniture and basket catalog proves that if it could be made from willow, Liverpool weavers could make it. Duerr was only eight years old when his father, Valentine, established the willowware business, but he was ready to take over when he reached adulthood. (Courtesy of Liverpool Village Museum.)

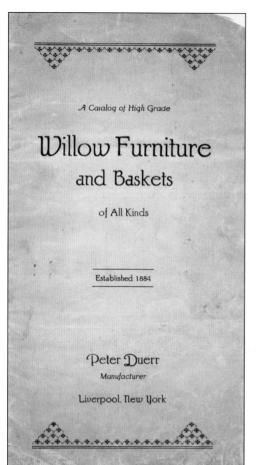

A Catalog of High Grade

Willow Furniture
and Baskets

of All Kinds

Established 1884

Peter Duerr

Manufacturer

Liverpool, New York

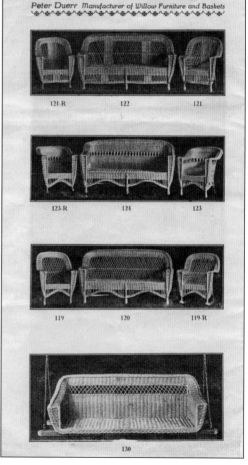

Peter Duerr *Manufacturer of Willow Furniture and Baskets*

121-R 122 121

123-R 124 123

119 120 119-R

130

Seating options from Duerr's furniture repertoire included several chair styles and a porch swing. The back cover offered custom options; rockers could be added to any four-legged chairs "at a small additional cost." Regarding staining, the catalog states, "We are prepared to stain articles of our manufacture in a very attractive shade of brown." Alternatively, customers could choose from a "wide range of very attractive Enamel finishes." (Courtesy of Liverpool Village Museum.)

This page of baskets from Duerr's catalog shows objects that were designed to appeal to the lady of the house. The top row is a series of baskets for flower gathering and arranging; beneath them is an array of sewing baskets, with and without handles, complete with spool holders. Next are objects intended for decoration and entertaining. Floral baskets, like No. 195, often had tin liners and were also used for funeral arrangements. (Courtesy of Liverpool Village Museum.)

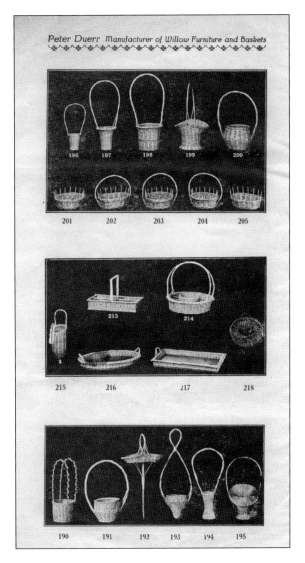

Peter Duerr
& Brothers

"The Firm That Put Will In Willowware"

Manufacturers of
Willow Furniture
and Baskets

DISPLAY ROOMS AND WORKSHOP AT 110 WILLOW ST., LIVERPOOL, N. Y.

Visitors Welcome at All Times

We are one of the oldest and largest manufacturers of willow furniture and willow ware in the United States and are prepared to handle special contracts, no matter how large. Careful attention given to special designs and colors.

Peter Duerr's furniture was not limited to porch and home use. He made and supplied furniture to Adirondack and eastern Canada hotels and resorts, seating for Thousand Islands tour boats, and closer to home, seating for the Palace Theater in Eastwood (now part of Syracuse, New York). In this October 29, 1922, newspaper advertisement, Duerr is soliciting "special contracts, no matter how large." (Courtesy of Liverpool Village Museum.)

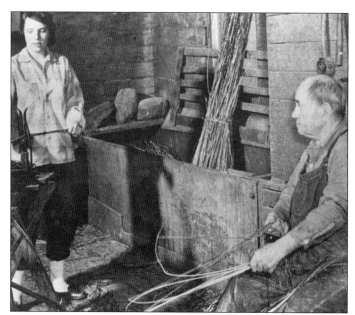

By 1957, Peter Duerr (1879–1962) worked alone, helped occasionally by a grandchild or nephew. His storeroom upstairs over the workshop was closed, but he continued to weave a few baskets to order. Here, Duerr and his granddaughter Charlotte Chapman are stripping willow. Charlotte is pulling a willow wand through a cracker to make the stripping process easier. The willow soak box in background holds a bundle of willow. (Courtesy of the Crawford Collection, Liverpool Public Library.)

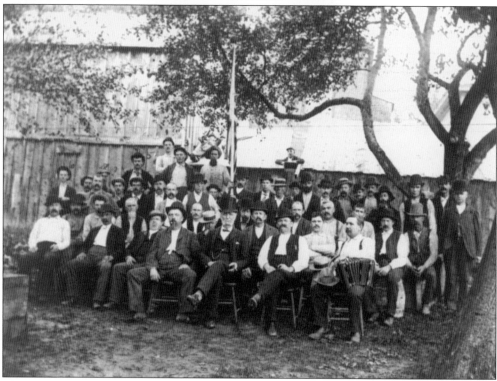

The Liverpool Basketmaker's Association was formed in the 1890s as a mutual benefit society and marketing agent for its members, old and young. This photograph was taken in 1895 in a backyard near Richberg's tavern at 209 Second Street. The president of the association, William Gleason, is seated at center. His suit and top hat indicate his prosperity as the brother of Lucius Gleason, "Liverpool's millionaire." William ran the Gleason family's store and coal interests and sold willow baskets to wholesale dealers. (Courtesy of Liverpool Village Museum.)

The Liverpool Basketmaker's Association parades east on First Street in 1895. Note the dirt road and wooden sidewalks, as well as buildings familiar to Liverpool visitors and residents today. The National Hotel, today called the Cobblestone, is in the center background. The two buildings on the corner still stand as well, today housing retail and office space. (Courtesy of the Schuelke Collection, Liverpool Public Library.)

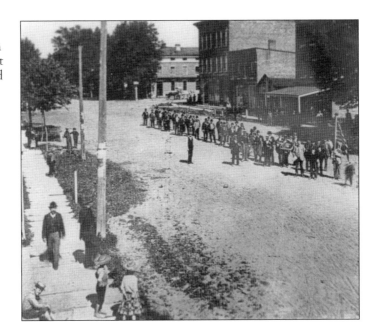

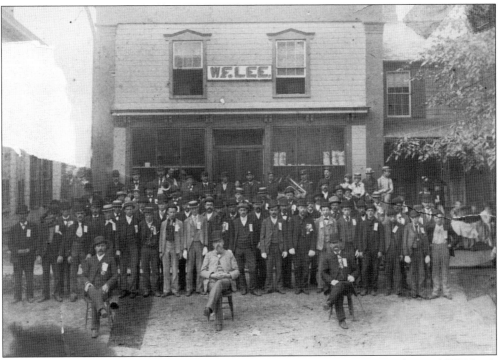

James T. Rogers photographed the Liverpool Basketmaker's Association in front of W.F. Lee's general store in the 1890s. The building had a venerable history; it was constructed in about 1825 as a school building and meetinghouse for local church congregations. It was purchased by the Methodists and moved from the park to Second Street around 1847, sold for a store in 1856, and torn down after a long commercial career in 1995. Today, the Liverpool Public Library owns the lot, which features gardens and dinosaur statues. (Courtesy of Liverpool Village Museum.)

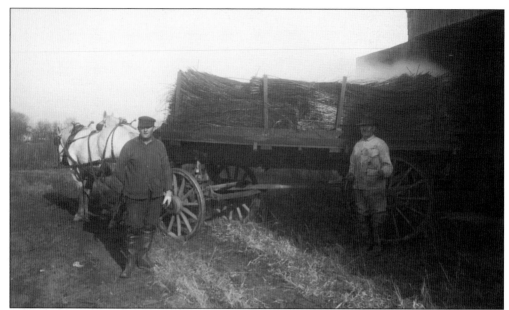

Harvested willow was bundled and then steamed to loosen its bark. The 100 block of First Street had a steamer operated by willow wholesaler L.L. Thurwachter, and another steamer was operated by Fred Wyker. A commercial steamer occupied the whole building, and wagonloads of willow were drawn into the building for steaming. This load of still-steaming willow is shown just emerging from a steamer barn around 1900. (Courtesy of the Crawford Collection, Liverpool Public Library.)

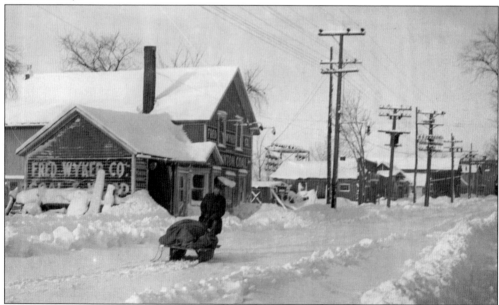

Fred Wyker was a man with many business interests, even serving for a time as Onondaga County sheriff. He purchased a coal yard from Judson McKinley in 1889. The Wyker Coal Company was located near the Wyker willow steamer at 115 First Street, across from Washington Park. A man pulls a loaded sled up the snow-covered street in this c. 1928 photograph. (Courtesy of the Schuelke Collection, Liverpool Public Library.)

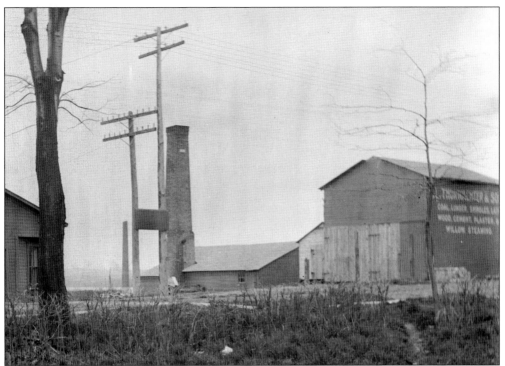

L.L. Thurwachter and Sons, located in the 100 block of First Street, dealt in coal, wood, cement, and plaster. Thurwachter also offered willow steaming and was thus a competitor of the Wyker coal and willow-steaming business. Because these two commercial steamers essentially controlled the price of steamed willow, there was talk of collusion between Thurwachter and Wyker to set prices artificially high. (Courtesy of the Schuelke Collection, Liverpool Public Library.)

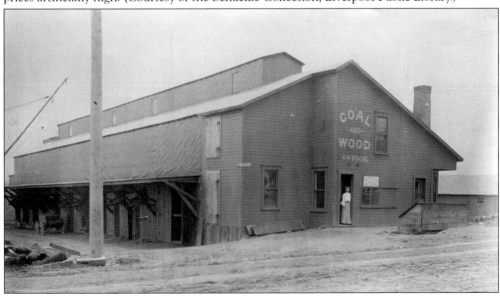

After Thurwachter delivered steamed willow to Liverpool basket makers, he in turn purchased the finished products for his wholesale business located in Syracuse. (Courtesy of the Schuelke Collection, Liverpool Public Library.)

BABY CARRIAGES

We have just received a carload of the celebrated Whitney Carriages, Go-Carts and Sulkys. For over sixty years these carriages have been a leader in their line and unsurpassed in quality and durability. Our order for these carriages was placed in the early part of 1919, and for this week and this week only, we are going to offer these exclusive 1920 models to the public with the price benefit of our early buying and are going to give

FREE one set of convertible carriage runners (valued at $3.50) to every purchaser of a carriage.

These Carriages are priced at **$25.00** and up

This is our **49th** year carrying this celebrated line of carriages.

L. L. THURWACHTER & SONS
"The House of Quality"
215 WEST FAYETTE STREET

L.L. Thurwachter's willow steaming business was on First Street in Liverpool, but the retail dealership and wholesale shipping operation was at 215 West Fayette Street in Syracuse. Thurwachter dealt in willow and other woven products made in locations other than Liverpool, as this February 28, 1920, advertisement shows. The Whitney Company was the first manufacturer of baby carriages in the United States. (Courtesy Joyce M. Mills.)

This Coupon Entitles the Purchaser
To $1.00 Discount

On any of our selected Willow Chairs or Furniture. This is an ideal opportunity to buy your porch furniture at greatly reduced prices. We have all grades and all prices. Come and inspect our stock.

L. L. Thurwachter & Sons
215 WEST FAYETTE STREET

Thurwachter offered this $1 coupon on April 5, 1921. Thurwachter's willow furniture stock likely came from many sources, including Liverpool willow furniture makers such as Peter Duerr and Charles Raupach. (Courtesy Joyce M. Mills.)

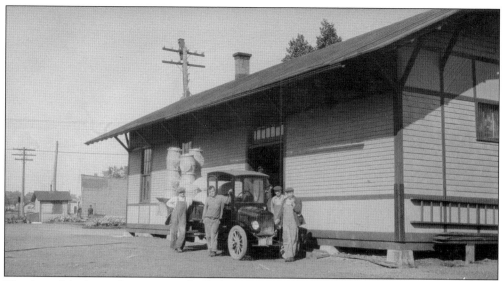

The days of the horse-drawn wagon loaded with willow hampers are gone. These willow hampers are being unloaded from a 1920s-era truck for shipment at Liverpool's second railroad station. This station was located by the tracks behind what is today Heid's hot dog stand. (Courtesy of the Schuelke Collection, Liverpool Public Library.)

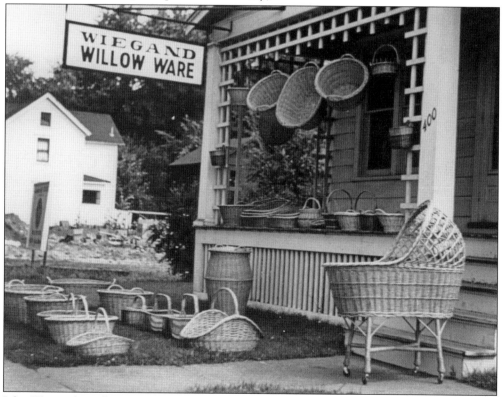

John Wiegand's Willow Ware Store was located at 400 Oswego Street, where the Wiegand family also lived. Baskets and other willowware are displayed on the porch and in the front yard of the house. (Courtesy of the Crawford Collection, Liverpool Public Library.)

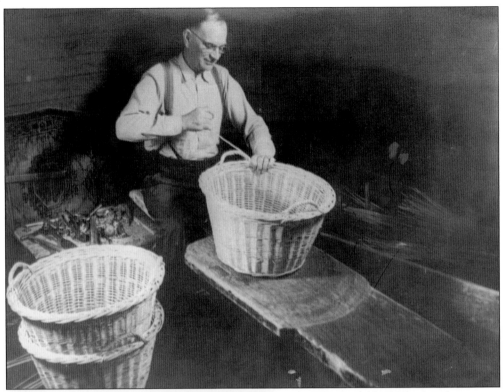

John Wiegand (d. 1981) sits at his workbench, which shows the wear of many baskets, as he puts the handles on a round willow laundry basket. Willow shops were not fancy places. The worn rug on the wall behind him is tacked up to help keep drafts off his back as he works. Two completed baskets sit to the left of the bench, as evenly made and identical as if turned out by machine. (Courtesy of the Schuelke Collection, Liverpool Public Library.)

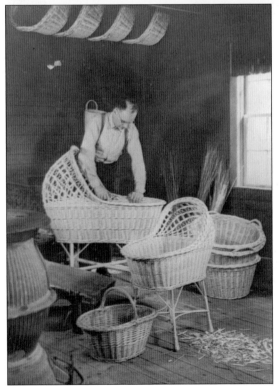

John Wiegand is trimming the willow ends around the top woven edge of a bassinet. In the 1950s and 1960s, Wiegand's shop and one or two others remained open on Oswego Street in Liverpool. Baskets for sale were hung on the makers' front porches and came to symbolize Liverpool for many people. (Courtesy of the Schuelke Collection, Liverpool Public Library.)

John Wiegand stacks finished laundry baskets in a storage shed while bundles of stripped willow wait in the rafters and on the floor. In an October 27, 1957, *Syracuse Post-Standard* article, Wiegand said, "So many cars go by so fast today that people find it hard to stop." He continued, "We couldn't get iron rods and dowels during the war so we stopped making furniture. Now we can't compete with mass-produced furniture. We can't even compete with other manufacturers' clothes baskets." (Courtesy of the Schuelke Collection, Liverpool Public Library.)

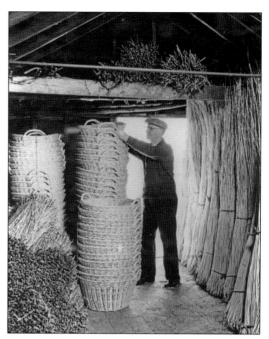

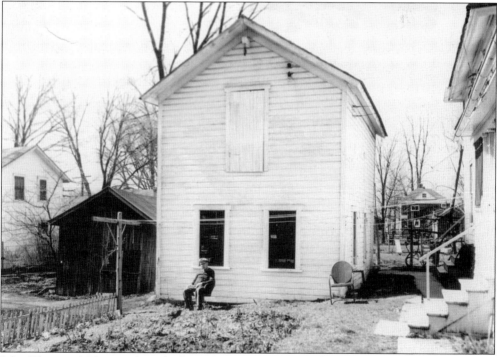

John Klippert (1884–1973) sits by his willow weaving shop at 103 Aspen Street. Willow shops were two-story frame buildings with an upper door in the peak for storing willow until needed. Weavers worked downstairs, warmed by a potbellied stove. Stripped willow bark, piled around the foundation for winter insulation, was burned in the spring producing a pungent black smoke. Many workshops have now been converted into garages. (Courtesy of the Schuelke Collection, Liverpool Public Library.)

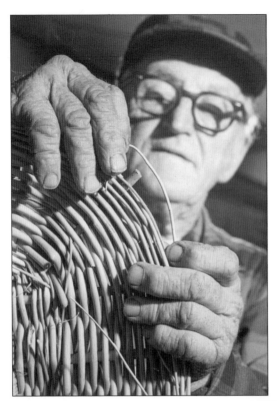

Pictured in 1991, J. Frank Selinski (1902–1994) works on the bottom of a willow basket. Selinski's childhood was spent in Liverpool, where he learned to weave. He had the sad distinction of being the last known willow weaver with Liverpool roots. (Photograph by Kathryn Loomis Smith; Courtesy of Liverpool Village Museum.)

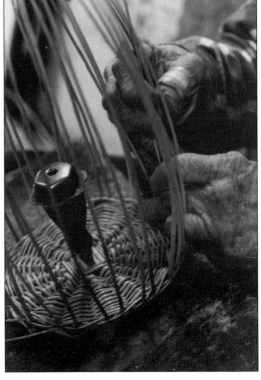

Here, J. Frank Selinski starts on the sides of a basket. The bottom is pinned to his workbench with an awl, so he can turn the basket as he weaves the sides. Because willow must be soaked to make it pliable for weaving, the work is damp. Selinski's hands are gnarled from a lifetime of weaving. (Photograph by Kathryn Loomis Smith; Courtesy of Liverpool Village Museum.)

J. Frank Selinski is at work in his shop in Munnsville, New York. The slotted rack on the left holds willow sorted according by size, ready for use in various parts of the basket. The thickest are called "bottom sticks," used for sturdy basket bottoms. Hanging on the wall on the right are some typical products, including an oval laundry basket and a handled market basket. (Photograph by Kathryn Loomis Smith; Courtesy of Liverpool Village Museum.)

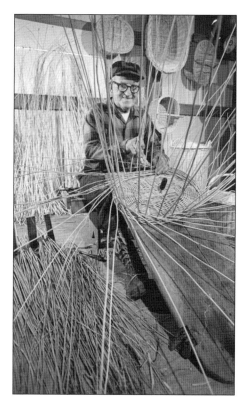

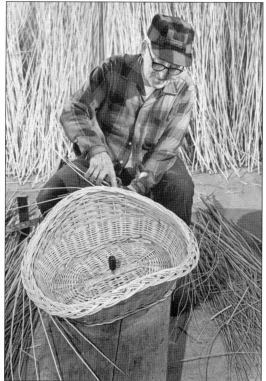

Selinski trims excess willow from a large willow basket. The braided-rim style is one of several typical of Liverpool willow baskets. In fact, the rim style is one of several identifying features of Liverpool baskets. Because Liverpool weavers did not sign their work, stylistic features and the purchaser's memory are the only ways to identify a Liverpool basket. (Photograph by Kathryn Loomis Smith; Courtesy of Liverpool Village Museum.)

Martin Hetnar was one of the last weavers in Liverpool. He displays his work in front of his home at 406 Oswego Street in 1924. Despite his ability to produce fancy ware and custom items, Hetnar continued to sell from his home until he stopped production only a few years before his death in 1975. Hetnar was unusual in that he had a small willow steamer in the shop in back of his house and did not rely on commercial steamers. (Courtesy of the Crawford Collection, Liverpool Public Library.)

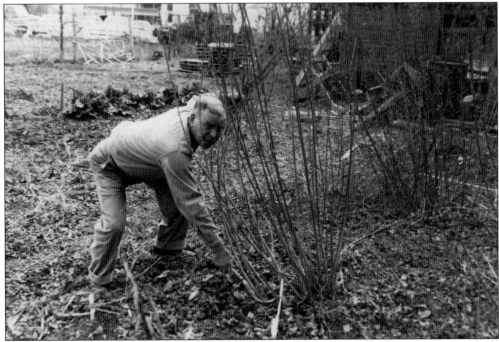

Martin Hetnar is harvesting one of the relatively few remaining willow stands, around 1930. He uses a curved knife to cut the willow whips close to the ground. Formerly, acres of basket willow had been grown around Liverpool. (Courtesy of the Schuelke Collection, Liverpool Public Library.)

Martin Hetnar (d. 1975) is at work in his shop at 406 Oswego Street in 1962. Hetnar was inventive and did custom work for customers outside the usual Liverpool products. The Liverpool Willow Museum collection includes a fishing creel and backpack made by Hetnar. (Courtesy of the Crawford Collection, Liverpool Public Library.)

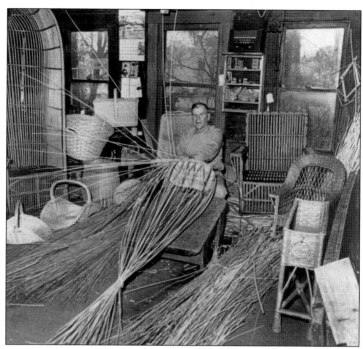

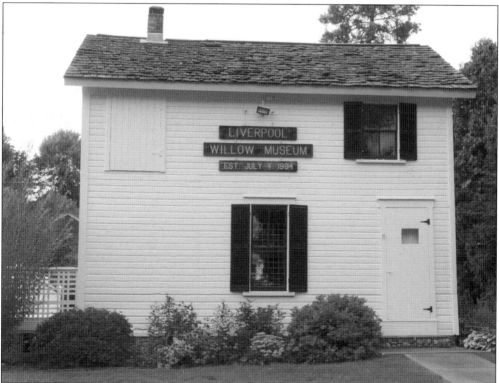

The Liverpool Willow Museum was formerly the Hurst family's willow shop. It was moved from Oswego Street to 314 Second Street in 1994. Today, it holds the tools, baskets, and other objects that evoke a vanished way of life. (Photograph by Joyce M. Mills.)

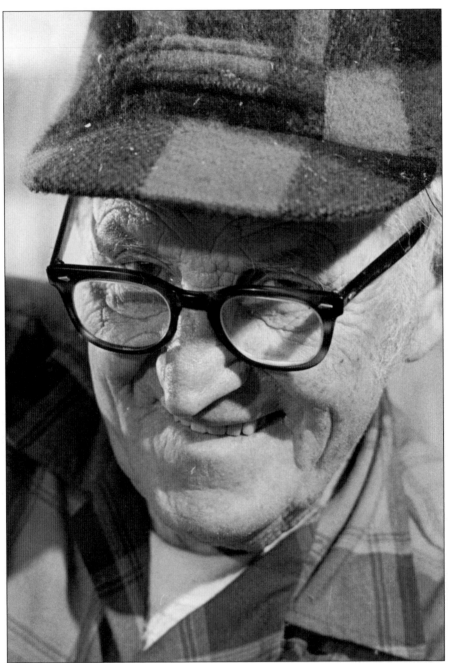

Seen in 1991, Frank Selinski was well aware of his place in history and delighted in giving demonstrations of his craft while telling stories of times gone by. His childhood was spent at 106 Cleveland Street in Liverpool village where he learned his weaving skills. He was the last of the Liverpool basket makers at his death in 1994 at the age of 92. There are others still remaining in Liverpool who have first-hand childhood memories of Liverpool's basket-weaving industry, but they too are now in their 90s. When they pass away, only recordings, images, and the baskets themselves will be left to tell about an industry that, in 1892, produced 360,000 willow baskets. (Photograph by Kathryn Loomis Smith; Courtesy of Liverpool Village Museum.)

Three

GROWING COMMUNITY

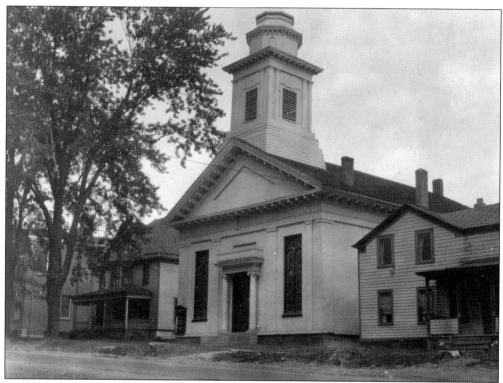

Liverpool's First United Methodist Church at 604 Oswego Street was built in 1856, but the congregation was actually founded in 1820. This photograph shows what the church looked like in 1928 when houses flanked it. The Masonic temple is at the far left, and a small section of trolley track is visible in lower-left corner, running down the still-unpaved street. (Courtesy of the Schuelke Collection, Liverpool Public Library.)

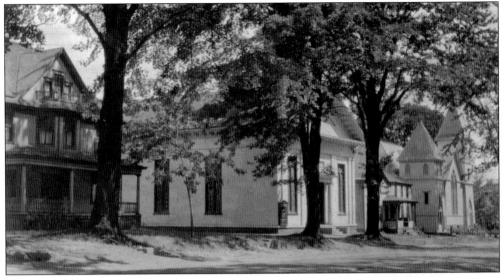

Trolley tracks run down the 600 block of Oswego Street in this September 1, 1928, photograph. From left to right are the Methodist Church parsonage (torn down in 1979), the Liverpool First United Methodist Church, the Weller house, and St. Paul's Lutheran Church. (Courtesy of the Schuelke Collection, Liverpool Public Library.)

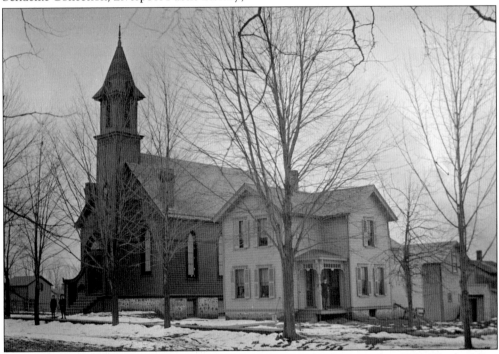

Trinity Church of the Evangelical Association was organized in Liverpool in 1844. The building pictured here, called the Little Pink Church or Little German Church, was built in 1886 at the corner of Vine and Hazel Streets. It was rededicated in 1932 after a fire, but the congregation dwindled and, 10 years later, the church was sold to the newly formed Episcopal congregation. The church finally burned beyond repair in February 1954. (Courtesy of the Crawford Collection, Liverpool Public Library.)

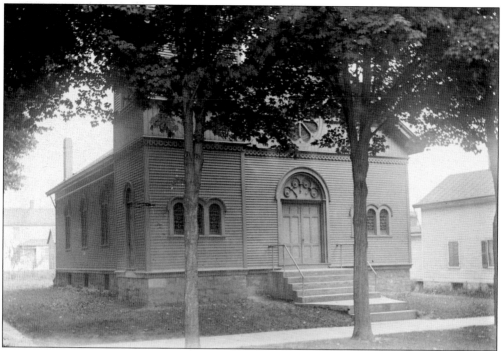

The cornerstone of St. Joseph's Catholic Church, pictured here around 1900, was laid in 1889 at the corner of Cypress and Oswego Streets. The church was enlarged in 1926, thanks to the proceeds from church suppers, card parties, raffles of live geese and chickens, and strawberry festivals. Plans for a new church were realized in 1953 when the church purchased its present site at Tulip and Sixth Streets. (Courtesy of the Schuelke Collection, Liverpool Public Library.)

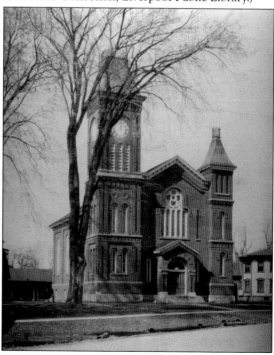

The 1862 First Presbyterian Church, shown here in April 1924, is located at the corner of Oswego and Tulip Streets in the center of the village. Generous donations from Liverpool's wealthy salt barons funded the imposing new structure, designed by prominent architect Horatio Nelson White (1814–1892). White's fee was $50. The clock in the tower was installed in 1892 and was originally the official village clock. (Courtesy of the Schuelke Collection, Liverpool Public Library.)

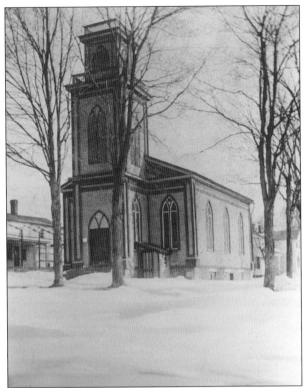

German immigrants to Liverpool and their families founded St. Paul's Lutheran Church. They purchased this building, which had housed the Episcopal Church of the Ascension, in 1853 for $1,200. The congregation was officially incorporated on January 31, 1854, but struggled until another influx of German immigrants in the 1880s strengthened it. (Courtesy of the Schuelke Collection, Liverpool Public Library.)

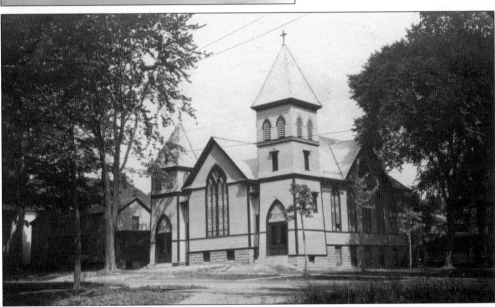

A new St. Paul's Lutheran Church was built in 1896–1898. It included stained-glass windows by Arts-and-Crafts artist Henry Keck. English services were added to those in German in 1924, but German services continued until 1941. Today, the building is an office building owned by the Liverpool First United Methodist Church. St. Paul's Lutheran Church now meets in a building on Hazel Street, which was dedicated in 1963 as an education center. (Courtesy of the Schuelke Collection, Liverpool Public Library.)

St. Paul's Lutheran Church celebrated its 75th anniversary in 1928. The members of the St. Paul Diamond Jubilee Choir are, from left to right, (first row) Phoebe Scholl, Mrs. John Gehm, Anna Wademan, Dorothy Lehne, and Elsa Raupach, organist; (second row) Frieda Heinzen, Jesse Waterhouse, Gertrude Smith, Clara Gildner, and Hilda Paneitz; (third row) Helen Wademan, Martha Schriener, Elizabeth Gildner, Margaret Scholl, and Henrietta Hackbarth. (Courtesy of the Schuelke Collection, Liverpool Public Library.)

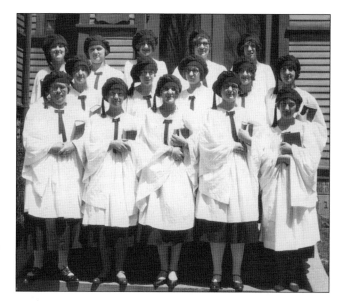

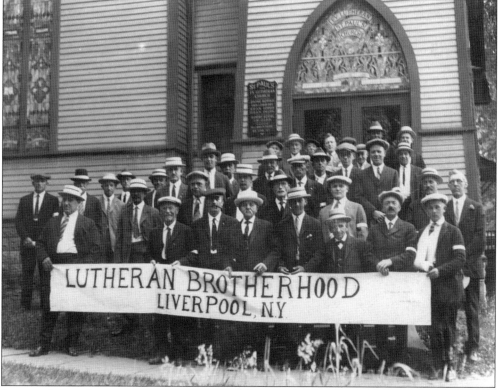

Liverpool church organizations were part of the social glue that held Liverpool together as community. In 1925, the Lutheran Brotherhood of St. Paul's had over 150 members. St. Paul's experienced successive waves of German immigrants from different areas whose culture and church customs differed. The congregation dwindled to a handful during the difficult years of World War I. But in 1925, the church was once more a strong presence in the community. (Courtesy of the Schuelke Collection, Liverpool Public Library.)

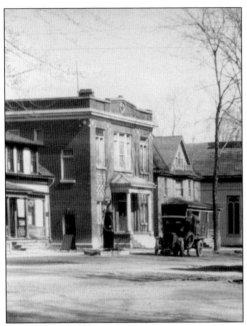

Masons were well represented among early Liverpool settlers. Liverpool Lodge No. 525, Free & Accepted Masons (F&AM) was chartered in 1862. The Liverpool Lodge No. 525 met upstairs at 301 First Street, and in various other meeting rooms on First Street, until it moved into its own building at 608 Oswego Street in 1918. The temple and Liverpool Lodge No. 525 still survive. (Courtesy of the Schuelke Collection, Liverpool Public Library.)

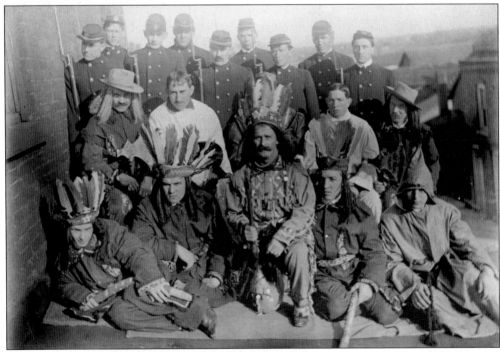

The Liverpool chapter of the Foresters of America, Court Liverpool 399 Degree Team, poses on a rooftop in 1904. The national organization was founded in 1874 as a fraternal and mutual benefit society, aiming to provide insurance for working families. They were unusual in that they also extended full membership to women, although none appear in this photograph. Nine are costumed in Civil War Union army uniforms, four are dressed as Native Americans, and two are dressed as cowboys while three appear in hooded robes. (Courtesy of the Schuelke Collection, Liverpool Public Library.)

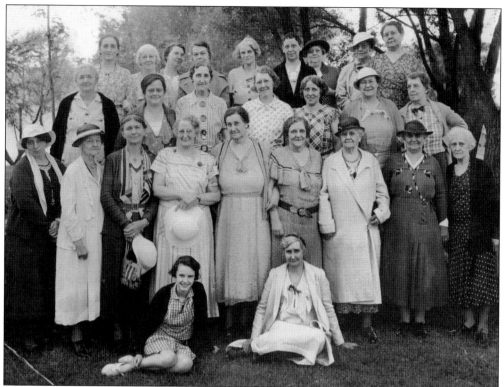

In October 1894, Liverpool teacher Anna O'Neill founded the Liverpool Historical Society. Inspired by a summer course at Chautauqua, O'Neill returned to Liverpool and started the study group with Kathryn Petit, Henrietta Boyden, and Mrs. C.R. Acker. At each meeting, a member would read a paper, followed by tea and a social hour. The society would become the oldest cultural organization in the village, finally disbanding in 2013. Here, the members and two young guests pose in June 1935 at a picnic at Willow Bay, Onondaga Lake. (Courtesy of Liverpool Village Museum.)

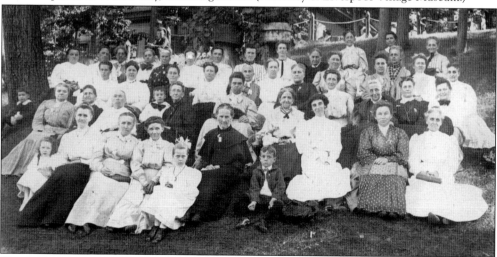

The Ladies Aid Society of the Liverpool United Methodist Church picnics at Long Branch Park in 1904. Apparently, posing for the photograph was serious business for many of the ladies! (Courtesy of Liverpool Village Museum.)

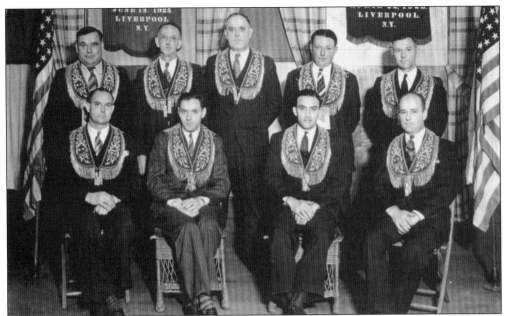

Liverpool Lodge No. 426 of the Independent Order of Odd Fellows (IOOF) poses in about 1934. Lodge No. 426 was instituted in 1925, but the Odd Fellows had an earlier presence in Liverpool as the Gilboa Lodge in 1847, disbanded in 1862. The Odd Fellows met on the second and third floors of the brick building on the northeast corner of First and Tulip Streets. Lodge No. 426 was declared defunct in 1959. (Courtesy of Liverpool Village Museum.)

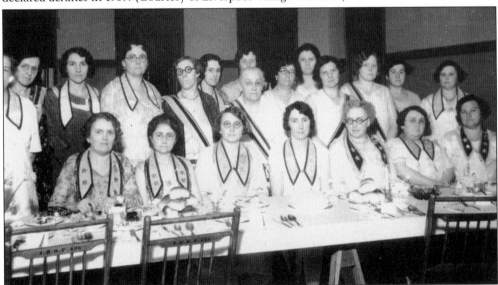

The Liverpool Rebekah Lodge No. 655, IOOF, was instituted on April 22, 1926. They sponsored a girls' organization, Mu Theta Rho Chapter No. 12, instituted on May 12, 1933, and the women took over a metal Quonset hut on Myers Road owned by the men of the lodge in 1966. The women's lodge persisted long after the men's group disbanded. The Rebekahs sold the Quonset hut in 1976 and then met in rented quarters and at the Elks Club on Route 370, just outside the village, until they consolidated with the Syracuse Rebekah Lodge in 1991. (Courtesy of Liverpool Village Museum.)

Liverpool Chamber of Commerce members cut the chamber's 35th anniversary cake in 1962. From left to right, they are Reverend Dudde, Fred Wackerle, Fred Wyker, and Charles Pratt. Founded in 1927, the chamber's purpose was to "advance the business, economic, civic, and social interests of the people of Liverpool." The Liverpool Chamber of Commerce merged with the Liverpool Businessmen's Association in 1975 to form the Greater Liverpool Chamber of Commerce. (Courtesy of Liverpool Village Museum.)

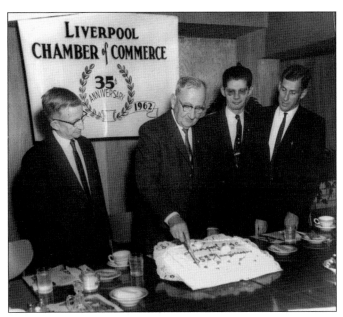

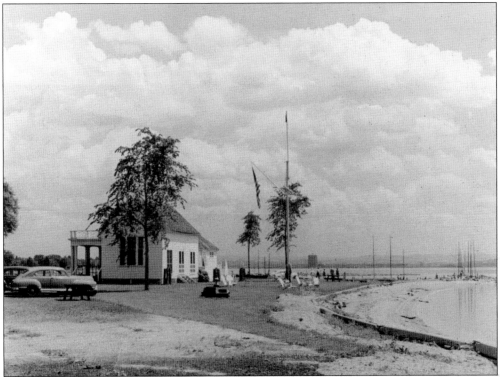

The Onondaga Yacht Club at Liverpool opened in July 1938. This scene, taken in July 1945, looks east toward Syracuse. The original Onondaga Yacht Club was founded in 1883, with a building on the opposite side of Onondaga Lake, making it one of the oldest boating organizations in New York State. The Onondaga Yacht Club at Liverpool still exists in the building shown here, but a large screen porch has been added to the lakeside of the building. (Courtesy of the Schuelke Collection, Liverpool Public Library.)

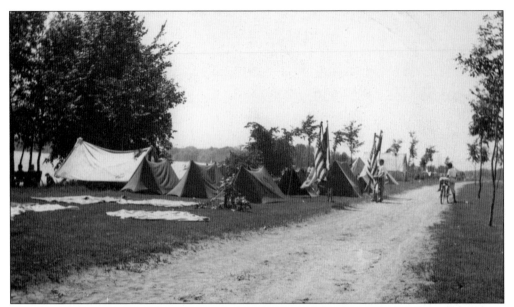

Here, Boy Scouts of America Troop No. 75 of nearby Mattydale, New York, raised the flag on June 26, 1937. Their tent camp on the Liverpool side of Onondaga Lake gave them the opportunity to practice outdoor skills. (Courtesy of the Schuelke Collection, Liverpool Public Library.)

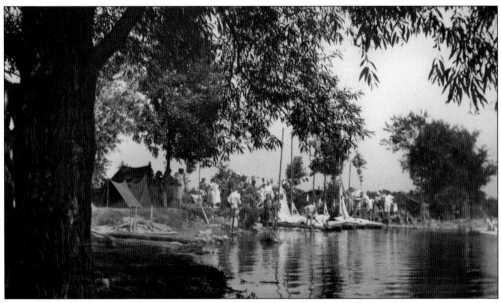

On June 26, 1937, spectators and Scouts watched the launching of small sailboats onto Onondaga Lake. The Scout camp provided practice in launching, boarding, and sailing the boats on the calm surface of the lake. (Courtesy of the Schuelke Collection, Liverpool Public Library.)

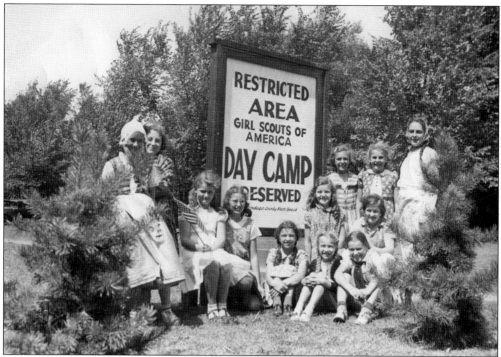

The 20th century saw the Liverpool side of Onondaga Lake evolve from an industrial area of salt blocks and canal to a recreation resource. This August 23, 1940, photograph shows the sign for a Girl Scouts day camp, as the participants gather around for the photograph. (Courtesy of the Schuelke Collection, Liverpool Public Library.)

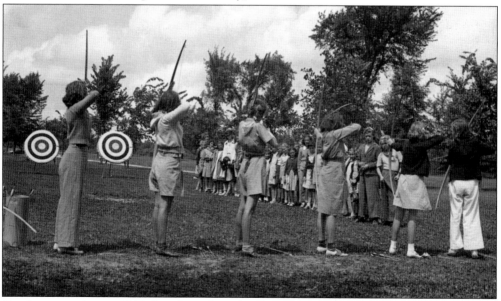

On that same August 1940 day, the girls at the Girl Scout day camp held an archery contest. While it is possible that the camp also included more traditionally "feminine" activities, the lakeshore afforded plenty of scope for exercise and sports. (Courtesy of the Schuelke Collection, Liverpool Public Library.)

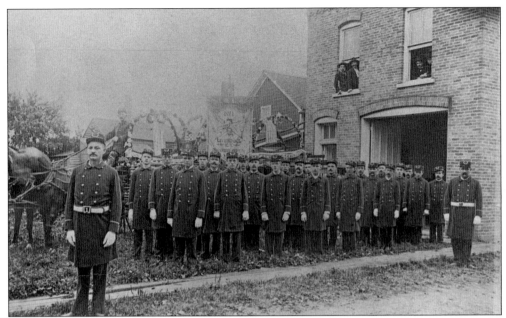

The members of Liverpool Volunteer Fire Department, Hook and Ladder Company No. 1, pose around 1890 in front of the engine house, built before 1886 on the corner of Tulip and Brow Streets about where Nichols Supermarket loading dock is today. Early records of the fire department list the occupations of its members: 30 basket makers, two butchers, a saloonkeeper, hotelkeeper, banker, painter, farmer, laborer, and a gentleman. (Courtesy of Liverpool Village Museum.)

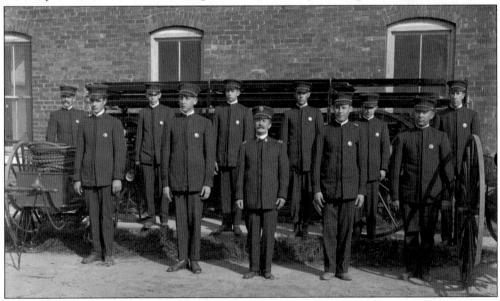

Hook & Ladder Company No. 1 was organized in 1882 and incorporated in 1888. Although they received no pay, village government began purchasing their equipment in about 1900. The officers are pictured here in 1915. From left to right, they are Rudolph Wetzel, Edward Walters, John Klippert, Roy M. Dinehart, Charles K. Dinehart, George W. Miller, Otis C. Lee, Daniel Dashley, Milton O. Cooper, Joseph Smilewski, and Edward H. Seibert. (Courtesy of the Crawford Collection, Liverpool Public Library.)

On December 17, 1927, an ice storm coats the trees and buildings surrounding the Liverpool First Presbyterian Church and the fire tower that stood in front of it. The 50-foot fire tower was part of an alarm system installed in 1914. The bell in the fire tower (later, a siren) also rang every evening at 8:00. The fire tower and the houses that flank the church in this photograph are now gone. (Courtesy of the Schuelke Collection, Liverpool Public Library.)

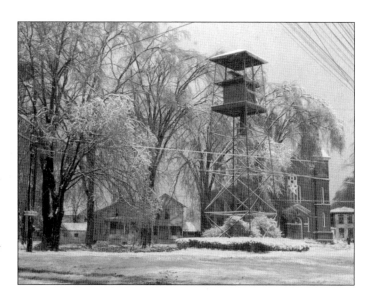

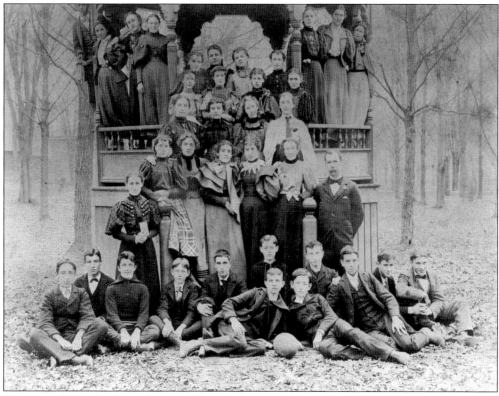

The entire high school population of Liverpool poses with teachers at the gazebo in Johnson Park, Liverpool, in 1896. The school stood on the corner of Second and Tulip Streets, where Liverpool Public Library stands today. Principal Manfred D. Greene stands at right behind the seated boys. (Courtesy of the Schuelke Collection, Liverpool Public Library.)

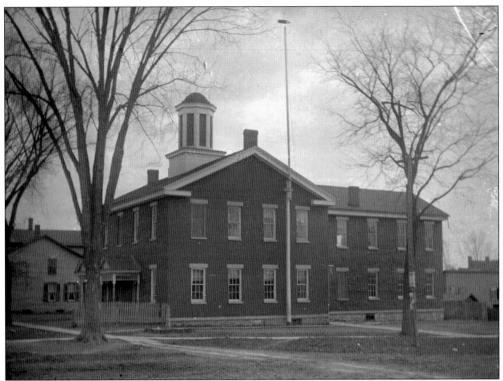

This view of the Liverpool Union School, built in 1848, was taken from the Tulip Street side. The two entrances in front of school on the Second Street side are separate doors, one for boys and one for girls. (Courtesy of the Crawford Collection, Liverpool Public Library.)

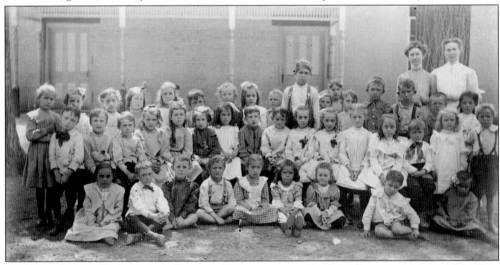

Forty-two first-grade children and two teachers pose outside of the Liverpool Union School in 1905. Some of the boys are barefoot; others from more prosperous families wear knee-length pants and boots. A new school building was erected in Johnson Park in 1814, a larger one took its place in 1827, and the Union School replaced that one in turn. The Union School was finally torn down in 1975 to make way for a new library. (Courtesy of the Schuelke Collection, Liverpool Public Library.)

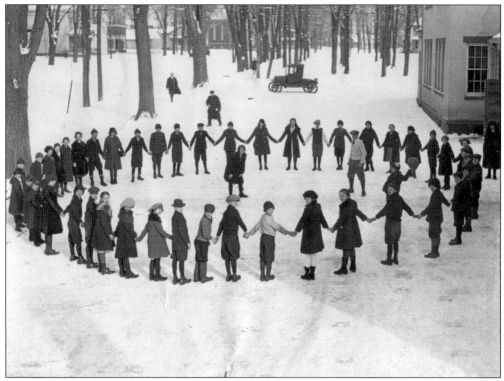

School children play a circle game in front of their school at the corner of Tulip and Second Streets. The 400 block of Tulip Street is at left, with the Presbyterian church in the center background. (Courtesy of Liverpool Village Museum.)

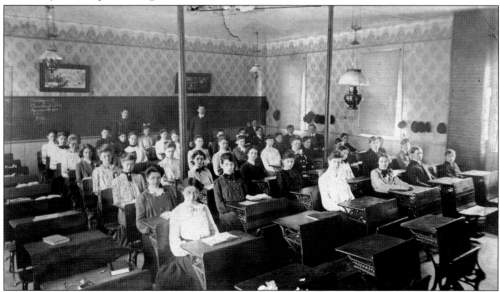

Liverpool's high school students sit at their desks in the Liverpool Union School in about 1903 under the watchful eye of their principal, Professor Tisdale. The girls are on one side of the room, the boys on the other. There are fewer boys than girls, because many boys left high school before graduation to earn a living. (Courtesy of Liverpool Village Museum.)

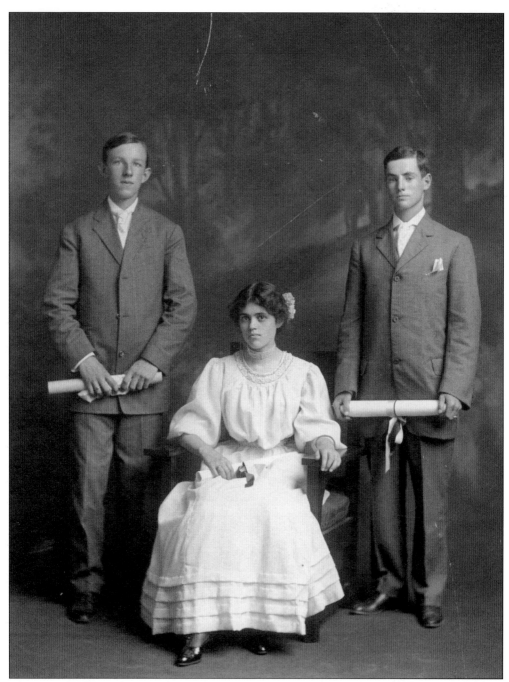

The entire 1907 graduation class from Liverpool High School poses proudly with diplomas. Pictured from left to right are Herbert Crawford, Joyce Houghton (later Allen), and Sherman Gleason. Herbert Crawford went on to fight in World War I. He survived the war, only to die in the influenza epidemic of 1918. Joyce Houghton Allen became a well-loved art teacher in the Liverpool school district and, later, served as village historian. She died in 1976. Sherman Gleason, a grandnephew of Liverpool millionaire Lucius Gleason, became a veterinarian who practiced in Niagara Falls, New York. Sherman died in 1963. (Courtesy of Liverpool Village Museum.)

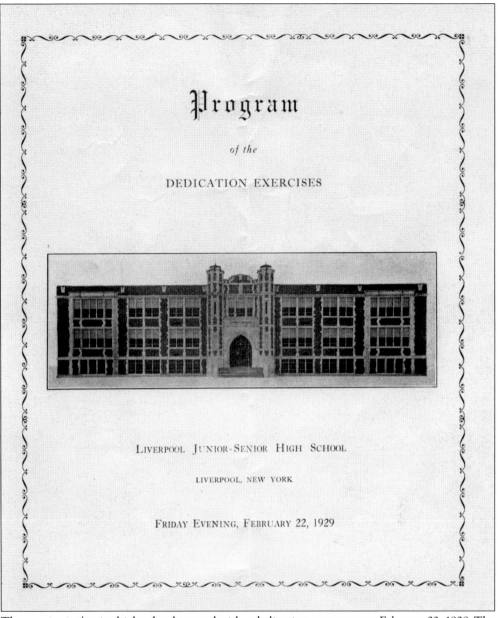

Program

of the

DEDICATION EXERCISES

LIVERPOOL JUNIOR-SENIOR HIGH SCHOOL

LIVERPOOL, NEW YORK

FRIDAY EVENING, FEBRUARY 22, 1929

The new junior/senior high school opened with a dedication ceremony on February 22, 1929. The program included a fact sheet about the building that emphasized its modernity compared to the 1848 school on the corner of Second and Tulip Streets, relegated to use as a grammar school. The new school featured fireproof construction, surfaced with "tapestry brick and trimmed with Onondaga Litholite." It boasted steam heat with thermostatic control, standard time clocks, and a sophisticated telephone system. Amenities included a modern cafeteria, an auditorium that seated 892 people, a gymnasium with bleacher seats for 600 spectators, and fully equipped science labs. Student capacity was about 800. The 1966 senior class was the last to graduate from the building, which, despite a new wing, had become severely overcrowded. Liverpool High School left the village soon after for its current location on Wetzel Road in the town of Clay. (Courtesy of Liverpool Village Museum.)

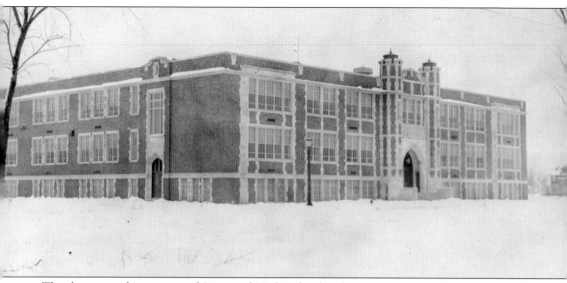

The then recently constructed Liverpool High School is shown as it appeared at the time of its dedication in February 1929. In 1925, the need for a new junior/senior high school for Liverpool village and the surrounding area had become apparent. The Liverpool School District voters approved the purchase of six acres of former willow fields from the Gettmann Estate, at the corner of Fourth and Hickory Streets in the village. In 1928, a bond issue raised $300,000 for design and construction of the new building. Syracuse architect Prof. Earl A. Hallenbeck (1876–1934), who designed several buildings on the Syracuse University campus, was engaged as the architect. The general contract was given to Dawson Brothers. (Courtesy of the Schuelke Collection, Liverpool Public Library.)

Four

ON THE STREET

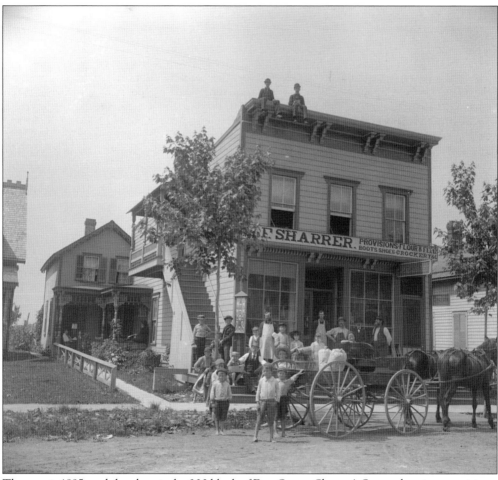

The year is 1895, and the place is the 300 block of First Street. Sharrer's Store advertises provisions, flour and feed, boots and shoes, and crockery, and displays a sign for a public telephone. A new exterior staircase leads up to James T. Rogers's photography studio on the second floor. Houses are visible on both sides of the store. Today, this area is a parking lot for Nichols Supermarket. (Courtesy of the Crawford Collection, Liverpool Public Library.)

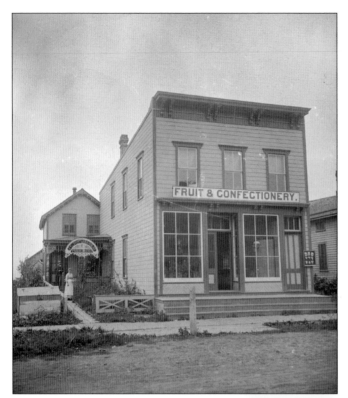

The Fruit and Confectionery Shop in the 300 block of First Street would become Scharrer's store, shown on the previous page. The ornate sign on the house at back reads, "Ice Cream Parlor." This is a pre-1895 photograph taken by James T. Rogers (1859–1937), whose studio was located above the store. The door leading up to the studio is on the right side of porch. Note the dirt street, plank sidewalks, and hitching post. (Courtesy of the Crawford Collection, Liverpool Public Library.)

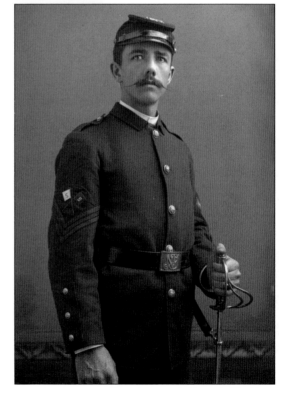

James T. Rogers, photographer, strikes a distinguished pose in his National Guard uniform with his hand on his sword. The back of the print has the logo of Rogers's own photography studio, advertising "Negatives preserved." (Courtesy of the Crawford Collection, Liverpool Public Library.)

Many photographs of 19th-century Liverpool were taken by the man-of-many-trades James T. Rogers (1859–1937). During his lifetime, Rogers was a photographer, jeweler, locksmith, and barber. Here, he is at work shaving a patron. Customers had their own shaving mugs, which are arranged in the cabinet on the right. (Courtesy of the Crawford Collection, Liverpool Public Library.)

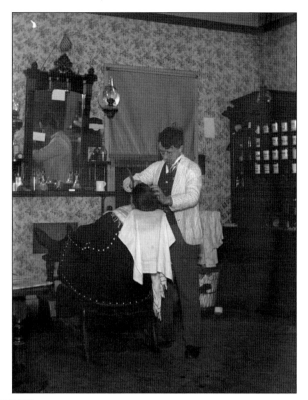

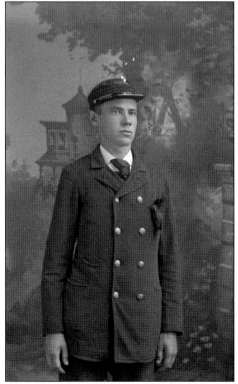

James T. Rogers was a popular studio portraitist. He took this photograph of young Liverpool native Corp. George "Mooney" Guess, who enlisted with other young men of the village to fight in the Spanish-American War. Guess served in Cuba and Puerto Rico, was honorably discharged, and promptly reenlisted. He was sent to Manila in the Philippines, where he died of typhoid fever in 1899 at the age of 23. (Courtesy of the Crawford Collection, Liverpool Public Library.)

The Jabez Olmstead (c. 1815–1876) house at 610 Oswego Street is seen from a vantage point in Johnson Park at the center of the village. The Greek Revival–style house was constructed in about 1840 and testifies to the community's growing wealth from salt. (Courtesy of the Schuelke Collection, Liverpool Public Library.)

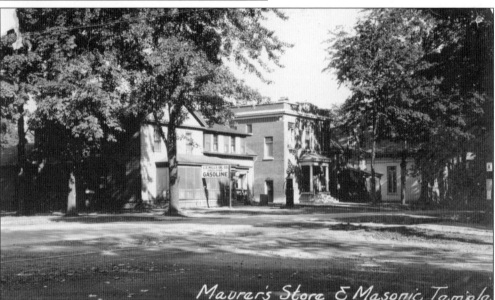

Fast-forward to 1924; the Jabez Olmstead house at the intersection of Oswego and Tulip Streets is Mamie Maurer's (d. 1944) store and gas station in this postcard. The road is unpaved and trolley tracks are visible on Oswego Street, but the familiar landmarks of the Masonic temple (to the right of the store) and the Methodist church (far right) are still there. (Courtesy of the Crawford Collection, Liverpool Public Library.)

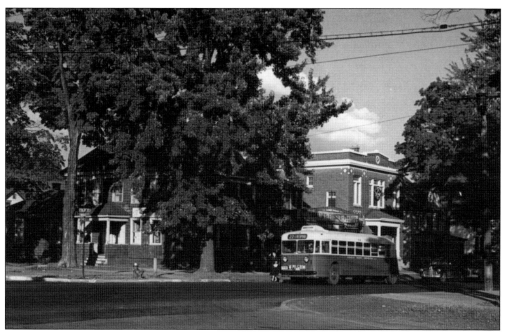

The year is 1952, and the place is the intersection of Oswego and Tulip Streets. The old Greek Revival Olmstead house, later Maurer's Store, is now Foley's Rexall Drug Store. The trolley is gone, and in its place, a Syracuse city bus has stopped in front of the drugstore to allow a woman to get off. (Courtesy of the Schuelke Collection, Liverpool Public Library.)

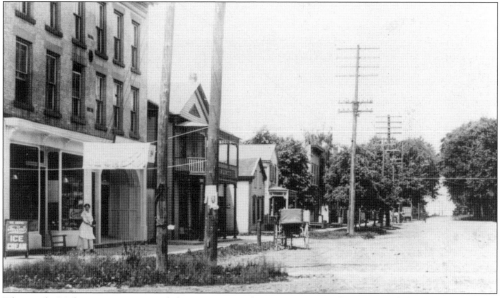

This early-20th-century postcard shows Liverpool's "Main Street" (First Street), looking west from the corner of First and Vine Streets. The building on the left, dating from around 1839, houses a grocery store, which proudly served ice cream, and a theater for silent movies. This building survives today as Nichols' Discount Liquors; the top two stories have been removed. Most of the remaining structures in the photograph are now gone, replaced by Nichols Grocery Store and parking lot. (Courtesy of Liverpool Village Museum.)

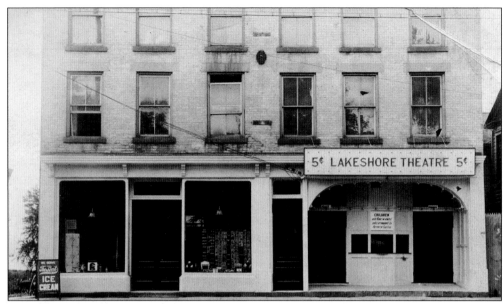

This 1839 building at 301 First Street, at the corner of Vine Street, is now Nichols' Discount Liquors. Constructed of brick made on First Street, it was designed as a double storefront with living quarters over the stores. In the 1920s, it housed the movie theater shown here, which featured silent movies with live piano accompaniment. Next, it housed a restaurant and tavern. Later, the deteriorating top two floors were removed. (Courtesy of Liverpool Village Museum.)

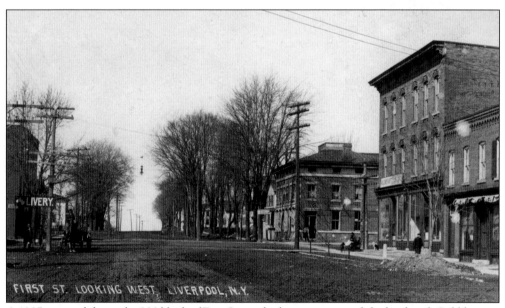

A 1905 postcard shows the 300 block of First Street, looking west toward the landmark Cobblestone Hotel. A horse-drawn wagon waits outside the livery stable on the left, today's Judy's Barber Shop. Martin Dinehart's store is on the right corner. The Cobblestone Hotel, the house next to it, and the buildings on the right have survived to the present. (Courtesy of Liverpool Village Museum.)

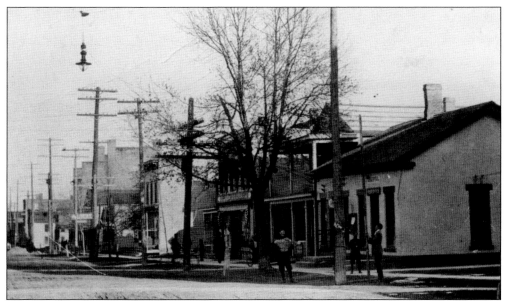

The corner of First and Tulip Streets, looking east down the lake side of First Street, was a dense business district in this c. 1903 postcard. The building on the corner is now gone. The next building was a wagon repair shop, later Myer's shoe store, and is now Judy's Barber Shop. The buildings beyond that were taken down for Nichols Supermarket and its parking lot. The tall building in the background had its top two floors removed and now houses Nichols' Discount Liquors. (Courtesy of Liverpool Village Museum.)

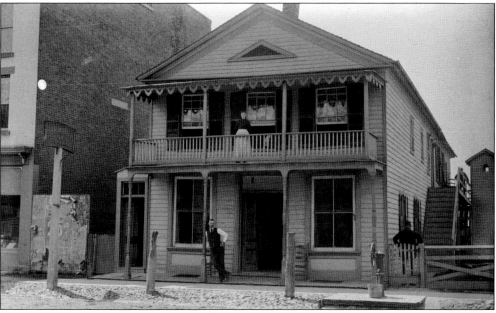

Balzhauser's Hotel was an early stagecoach stop that later became a popular local restaurant. This small two-story tavern and hotel, located at 309 First Street, is shown here around 1890. Note the two-story outhouse on the right and the water pump located along edge of unpaved First Street. The building was torn down in 1973, and the land was turned into a parking lot. (Courtesy of the Crawford Collection, Liverpool Public Library.)

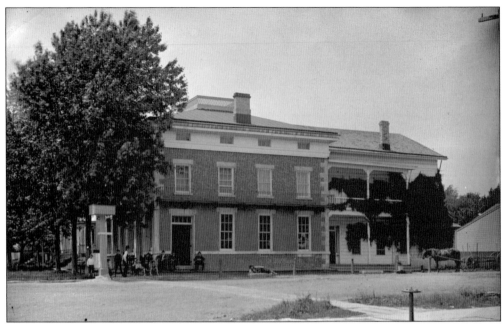

The National Hotel at the corner of First and Tulip Streets was built in 1839 for Jonathan Hicks (1791–1866), who also constructed a cobblestone house on the corner of Vine and Aspen Streets, Liverpool. Both structures were built from water-rounded stones drawn by oxcart from Lake Ontario. Designed by H&W Clark, the National Hotel is a rare example of a Greek Revival commercial structure, shown here around 1890. (Courtesy of the Crawford Collection, Liverpool Public Library.)

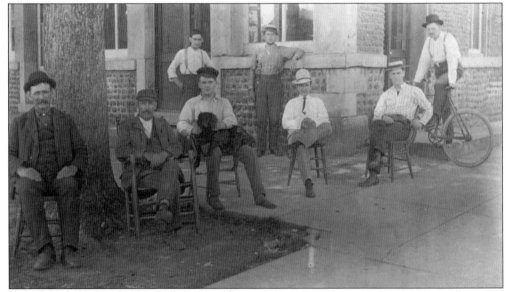

The entry to the National (Cobblestone) Hotel was a good place to keep an eye on things at the turn of the century, just as it is today. The seated men are, from left to right, George Dowd, Frank Gleason, George Richberg Jr., Frank Alvord, and Ray Duell. Oliver Pease (left) and Bill Naumann are standing, and Harve McCord has thrown one leg over his bicycle. (Courtesy of Liverpool Village Museum.)

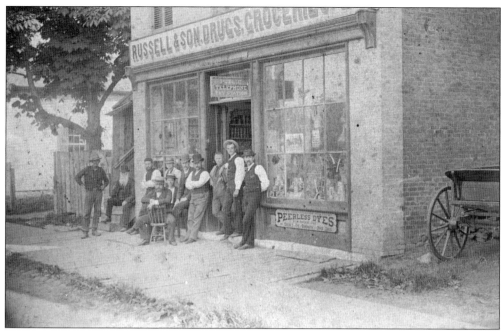

Another good place to keep an eye on the street in 1903 was the front stoop of Russell & Son, Drugs, Groceries store on Tulip Street. The men are, from left to right, Doc Van Alystyne, Counselor Nathaniel King, George Russell, Irving O'Neil, L.D. Tyler, Charles G. Alvord, Eugene Freeman, William Gleason Jr., and Frank Williams. Seated in front is Dr. A.B. Randall, whose office was around the corner on First Street; seated behind him is Frank Young. Today, the Russell's Drugs Building houses the Liverpool Shoe Repair shop. (Courtesy of Liverpool Village Museum.)

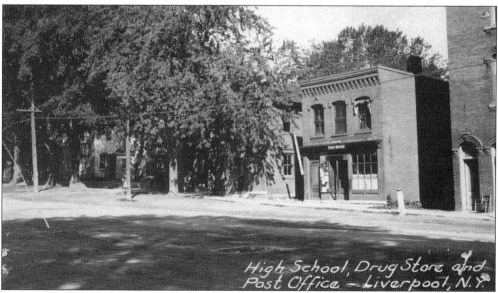

The building mostly hidden by trees in this later photograph is Russell & Son Drugs, Groceries. The next building to the right of it shown in this postcard was the post office. It later became a barbershop and is an insurance agency today. (Courtesy of Liverpool Village Museum.)

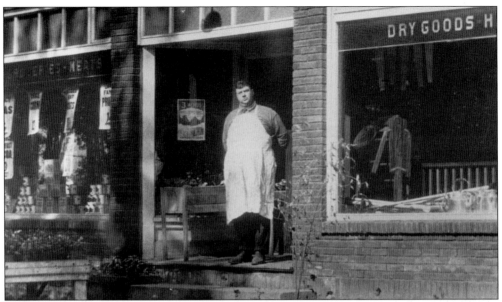

William Frank poses in the doorway of his store located at 407 Oswego Street, near the corner of Tulip and Oswego Streets. Frank's store carried something for everyone—groceries, meats, dry goods and hardware, as the sign advertises—before the age of chain supermarkets and big-box hardware stores. This building later housed Fred Wagner's Liverpool Hardware Store, a fabric store, Liverpool Stationers, and now the Café at 407. (Courtesy of the Crawford Collection, Liverpool Public Library.)

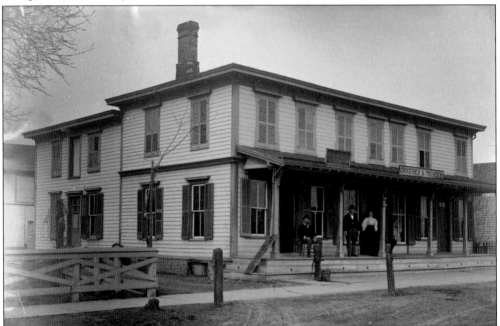

George Schafer's saloon and store at 304 Oswego Street offered refreshments, a hitching post, and a water pump to passing traffic. This building, now gone, housed Heid's Grocery Store for a time and, later, the Town of Salina Offices. (Courtesy of the Crawford Collection, Liverpool Public Library.)

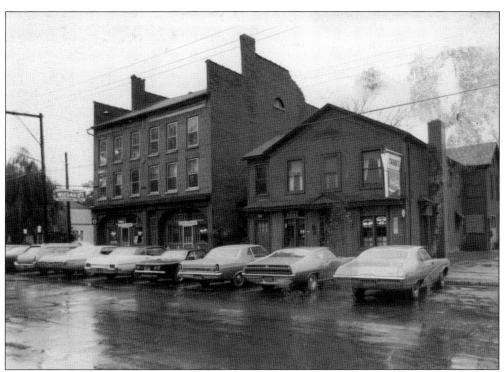

Tarbe's on First Street, seen around 1970, was the place to go for the best hamburger in town. The restaurant enjoyed lunch customers from nearby General Electric, an industry that was booming at that time. The restaurant had had a long career, starting as Balzhauser's tavern in the 19th century. It was finally demolished to make way for Nichols Grocery Store parking lot. (Photograph courtesy of Russ Tarby Jr.)

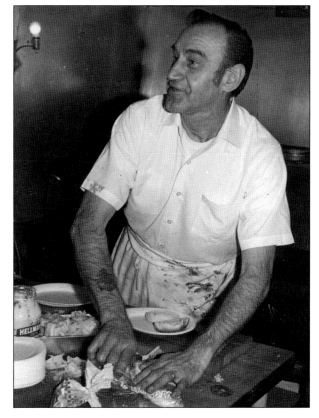

Russell Tarby Sr. (1922–1991) makes hamburgers in the restaurant he ran with his brothers, who spelled the name Tarbe. After the restaurant closed, Tarby took his hamburger genius to other restaurant kitchens and charitable events. He was also a talented writer and conversationalist. (Photograph courtesy of Russ Tarby Jr.)

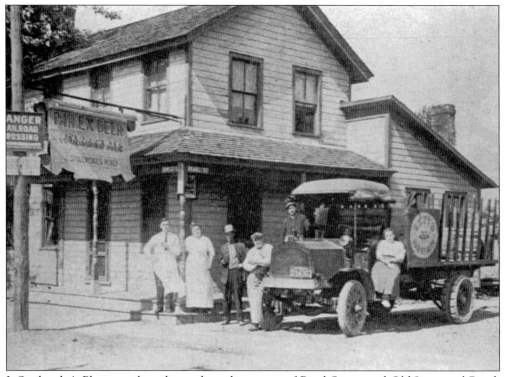

J. Smilewske's Place, a saloon located on the corner of Pearl Street and Old Liverpool Road, receives a delivery of Zetts beer. The old saloon's last incarnation was the BeBop Shop, a music store torn down in 2000. (Courtesy of the Crawford Collection, Liverpool Public Library.)

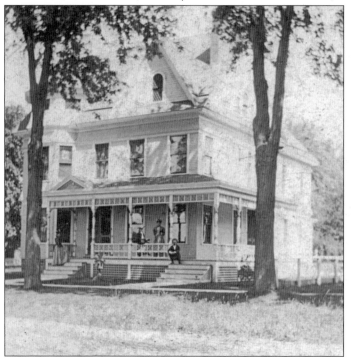

Some fine houses counterbalanced Liverpool's homely saloons. James Griffin Miller (1840–1920), a Liverpool builder, specialized in Queen Anne Revival–style houses in the 1890s. This grand one at 412 Second Street was built in 1893 for the McCord family, and features the gingerbread trim, expansive porch, and round tower typical of this style. The house was considered to be a "corker" [a fine one] by local residents. Bradley Gillis took photograph in 1896. (Courtesy of Liverpool Village Museum.)

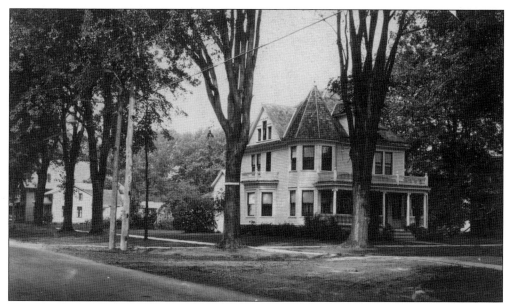

This house at 301 Sycamore Street is said to be an undocumented design of Ward Wellington Ward (1875–1932), the Arts-and-Crafts architect whose home was on Old Liverpool Road. Local builder Royal Houghton constructed it in 1909 for Frank S. and Nellie Fairchild. (Courtesy of Liverpool Village Museum.)

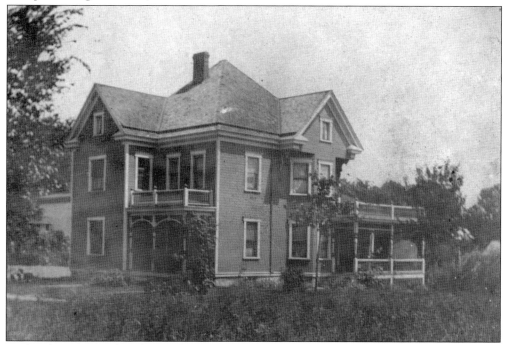

Fred and Minnie Wyker's late-19th-century house at 602 Vine Street is a Queen Anne Revival example of what prosperous Liverpudlians considered a stylish home at the time. Wyker (1864–1935) had a prosperous coal and willow steaming business in the 100 block of First Street and served as Onondaga County sheriff. Today, this house is an attorney's office. (Courtesy of Liverpool Village Museum.)

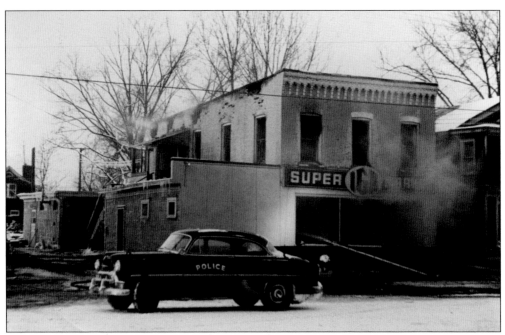

Nichols Grocery Store, Nichols IGA, and the current Nichols Supermarket represent a lineage of grocery stores, owned over the years by the Nichols and then Hennigan families. The building shown here after a devastating fire on December 24, 1953, was rebuilt and enlarged. (Courtesy of the Schuelke Collection, Liverpool Public Library.)

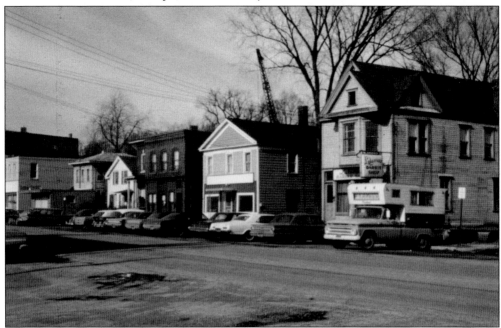

In March 1968, one could still see the remnants of the 19th-century business and residential block on the north side of First Street, between Tulip and Vine Streets. The crane in the background hints at the fate of these buildings. They were demolished for the Village Mall, a combined retail/office and apartment building that occupies the site today. (Courtesy of Liverpool Village Museum.)

Five

HAVING FUN

Young women posed with their pneumatic-tired "safety" bicycles, an improvement over the high-wheel bikes of the 1880s. Laura Edwards (later Howard), on the left, was the daughter of Civil War veteran Charles E. Edwards of 601 Second Street. Her friend Georgianna Mathewson (later Alvord) was born in Geddes but often stayed with her sister Harriet Young at 419 First Street. Laura and Georgianna were both born in 1880, spent all or most of their lives in Liverpool and lived until 1981 and 1971 respectively—a century's worth of experience. (Courtesy of Liverpool Village Museum.)

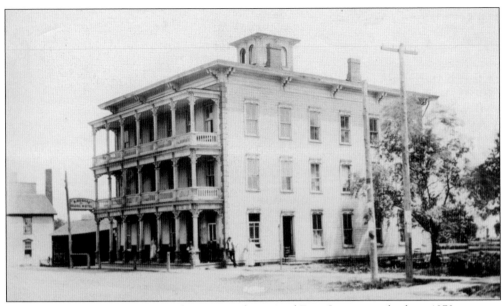

Alonzo Godard's Globe Hotel at the corner of Vine and First Streets was built in 1873 on a site that had held taverns since the early 1800s. The Globe served a busy and increasingly prosperous canal village. It provided a stagecoach stop, dance hall, practice room for the Liverpool Hook & Ladder Band, a hall for meetings, performances, and a dancing school, and a center for social events. The Globe burned in 1900. Arson was suspected but never proven. (Courtesy of the Schuelke Collection, Liverpool Public Library.)

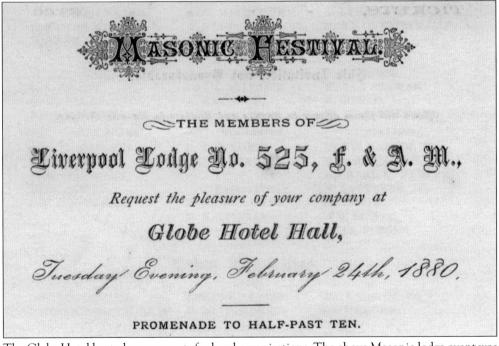

The Globe Hotel hosted many events for local organizations. The above Masonic lodge event was held at the Globe on February 24, 1880. Liverpool Lodge No. 525 dates to 1862, but the Masonic presence in Liverpool dates to its earliest settlers. (Courtesy of Liverpool Village Museum.)

This lovely invitation to a Masonic lodge festival dates to December 29, 1882. Some events were not quite as refined. Frank Miller (1879–1968) wrote in his unpublished memoir, *Places of Prominence and Events of the Past* (1966), "Quack medicine men would drive up in front of the Cobblestone or the Globe Hotel offering their bargains to an anxious public. . . . One time some of spectators unhitched the horse and when the medicine man was ready to say goodbye to the suckers, the horse went ahead without the wagon or the faker." (Courtesy of Liverpool Village Museum.)

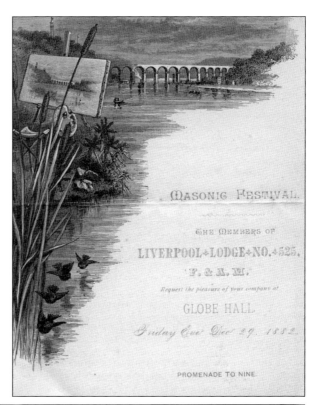

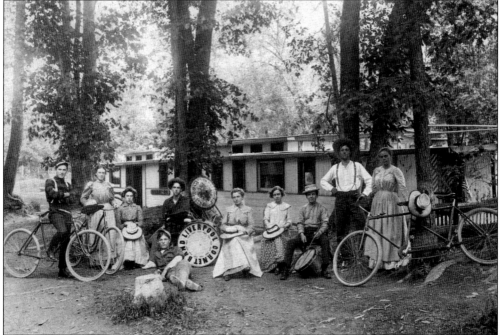

The Liverpool Cornet Band poses with the excursion boat *Rambler* in this undated photograph taken by the shore of Onondaga Lake. The couple on the right is lucky to have a bicycle built for two. The young people's hatbands read "Camp Rambler." (Courtesy of Liverpool Village Museum.)

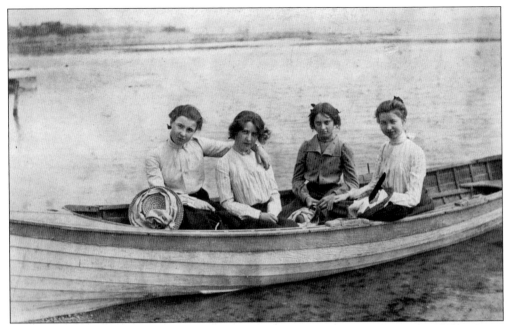

Liverpool teens relax in a rental boat on Onondaga Lake in this undated photograph by George W. ("Waxy") Miller. The lakeshore opposite Liverpool was dotted with resorts that were easily reached by boat or by trolley, and as life became a bit more leisurely the resorts afforded amusement to young and old. (Courtesy of Liverpool Village Museum.)

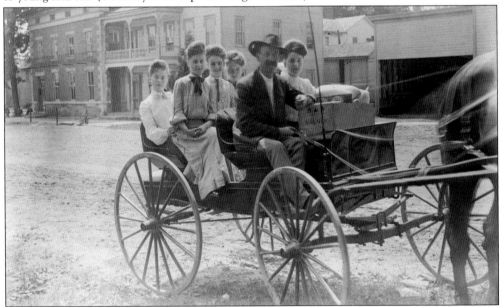

What does a 1915 teenage girl do? She puts her hair up in Gibson-girl style and talks her father into a ride with her friends. Here, they are on Tulip Street. Martin Dinehart is at the reins. The National Hotel (Cobblestone Hotel) is in the background, and the hotel's livery stable is on the right. The girls are, from left to right, Ella (Godard) Bassett; Clara (Fischer) Bittel; Marion (Alvord) Jackson; Louise (Dinehart) Gilroy; and Martin's daughter Minnie (Dinehart) Benjamin. (Courtesy of the Schuelke Collection, Liverpool Public Library.)

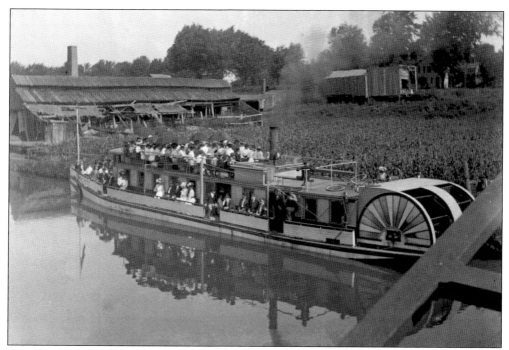

The *Eugene Petit*, a steam-powered sternwheeler, is tied up at Crawford's dock near the foot of Sycamore Street around 1900. The boat is taking a group to a Sunday School picnic at Long Branch Park. (Courtesy of the Schuelke Collection, Liverpool Public Library.)

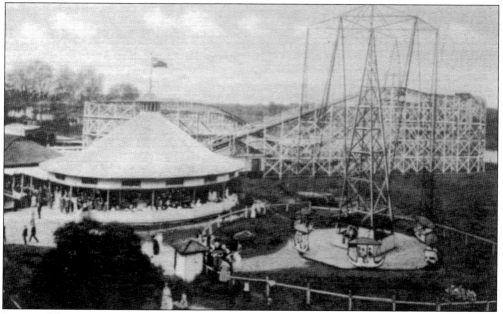

Liverpool businessmen Ben and George Maurer opened Long Branch Amusement Park at the western end of Onondaga Lake in 1883. Of all the resorts that lined the shore of the lake in the late 19th and early 20th centuries, Long Branch was the farthest from Syracuse but proved to be the most popular. This 1910 postcard shows some of the amusements offered. (Courtesy of the Schuelke Collection, Liverpool Public Library.)

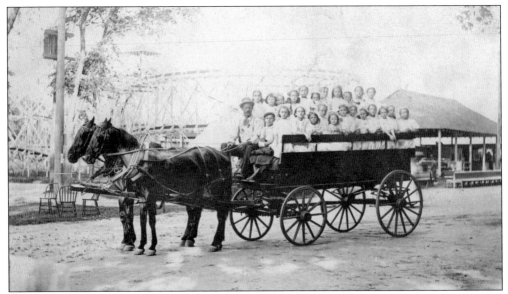

James K. Hart (1863–1925) poses for a postcard with a wagonload of children at Long Branch Park in 1907. The park's wooden roller coaster is visible in the background. Hart ran a livery service and served a time as chief constable for the Village of Liverpool. (Courtesy of Liverpool Village Museum.)

A freak tornado touched down in the area on September 15, 1912, at Long Branch Park, the Keith farm on nearby Cold Springs Road, and at Pitcher Hill in North Syracuse. This postcard shows the wreckage of trolley Car No. 3, which was blown off the tracks at Long Branch Park. One person died in the trolley car accident, and the amusement park was destroyed. (Courtesy of the Schuelke Collection, Liverpool Public Library.)

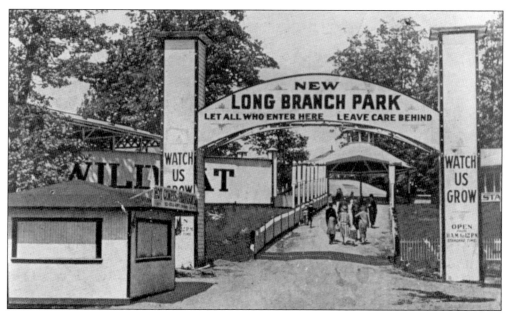

After the 1912 tornado's destruction, the park was rebuilt and a new Long Branch Park rose in its place. This postcard shows the main entrance gate in the early 1920s. The new park finally closed in 1937, after a long history of both amusing and employing Liverpool residents. (Courtesy of the Schuelke Collection, Liverpool Public Library.)

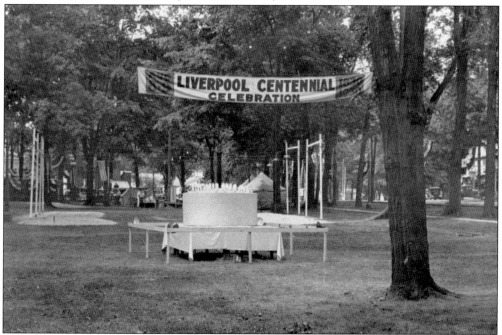

Liverpool celebrated the 100th birthday of the village's incorporation on August 8 and 9, 1930. Festivities, the highlight of which was the birthday cake with 100 candles, took place mainly in Johnson Park in the middle of the village. Events included outboard motorboat racing, a baseball game, a water fight among firemen, and music by Dan's Boys, a 75-member Liverpool fife, drum, and bugle corps. (Courtesy of the Schuelke Collection, Liverpool Public Library.)

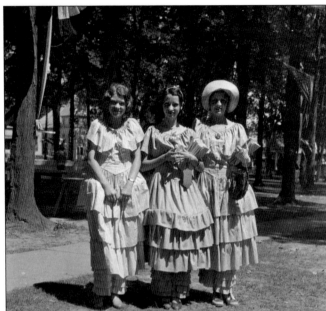

Three young women in costume sell programs and books on August 9, 1930, for the centennial celebration. From left to right, they are Betty Lehne (Rosenberger), Evelyn Bates (Conklin), and Jeanette Miller (Hanford). Among other events, the celebration featured many local residents in costume and a special exhibit in the old school on the corner of Second and Tulip Streets. (Courtesy of the Schuelke Collection, Liverpool Public Library.)

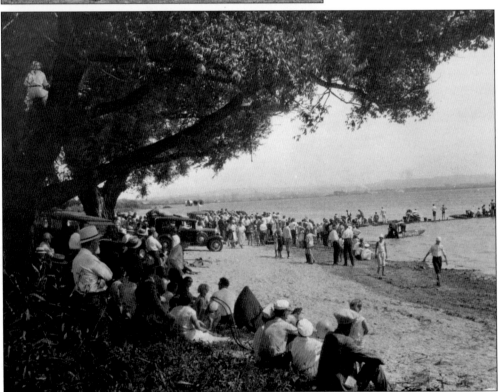

A crowd gathers along the Liverpool side of Onondaga Lake to watch the outboard motor boat races that were part of the 1930 Liverpool Centennial Celebration. The cluster of speakers visible above the cars near the center of the photograph carried announcements over the roar of the boats. The centennial celebration also featured airplanes circling over the village, providing stunt flying and parachute jumps. (Courtesy of the Schuelke Collection, Liverpool Public Library.)

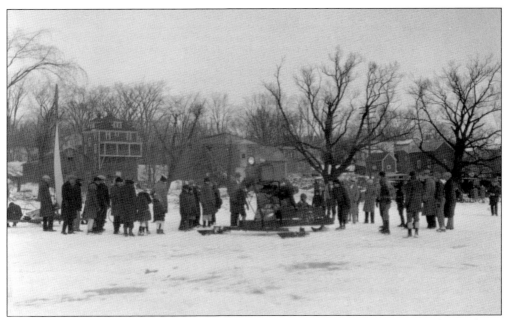

An iceboat powered only by wind in its sails could speed across the ice of Onondaga Lake at more than 60 miles per hour. Here, a crowd gathers to watch a 1928 innovation—a "motor ice yacht" owned by Ralph Grimshaw. A traditional sail-powered iceboat is at the left, and the backs of houses in the 500 block of First Street are in the background. (Courtesy of the Schuelke Collection, Liverpool Public Library.)

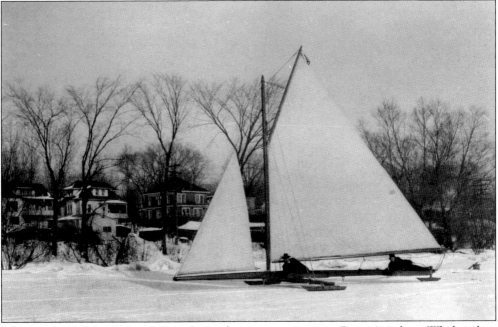

John Rogers (1894–1958), on the right, and companion pose on Rogers's iceboat *Whirlwind* on February 11, 1928. The backs of houses in the 600 block of First Street are in the background. Rogers designed and built iceboats in his workshop at 610 First Street. (Courtesy of the Schuelke Collection, Liverpool Public Library.)

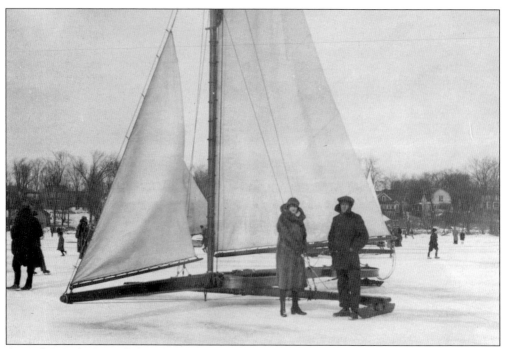

Onondaga Lake provided recreation for Liverpool residents in both summer and winter. An unidentified couple dressed for the weather pose in front of an iceboat on February 16, 1928, while skaters whirl around them. By mid-century, pollution had raised the temperature of the lake to the point where it rarely froze solid enough for skates and iceboats. (Courtesy of the Schuelke Collection, Liverpool Public Library.)

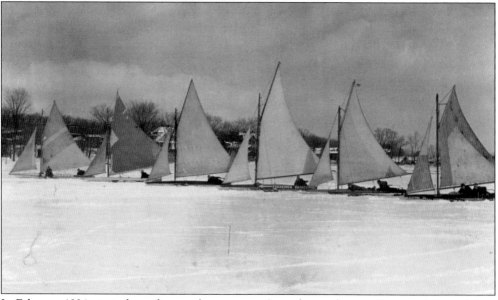

In February 1934, six iceboats line up for a race on Onondaga Lake near Liverpool. From left to right, they are identified by the photographer as Norman Wiegand's *Question Mark*, Eddie Green's *Flirt*, Chuck Beneke's *Black Devil*, Eddie Barnes's *Frederick Barnes*, Olly Pease's *Flapper Fanny*, and Hank Daucher's *Emmy*. (Courtesy of the Schuelke Collection, Liverpool Public Library.)

Liverpool racer Raymond Wiegand (1907–1986) crosses the finish line in his boat, the *Question Mark*, while Chuck Beneke and an unidentified companion trail in the *20th Century*. In the winter of 1935, when this photograph was taken, Onondaga Lake still froze solid enough to support iceboat racing and skating. At this time, though, ice was no longer harvested from the lake due to pollution. (Courtesy of the Schuelke Collection, Liverpool Public Library.)

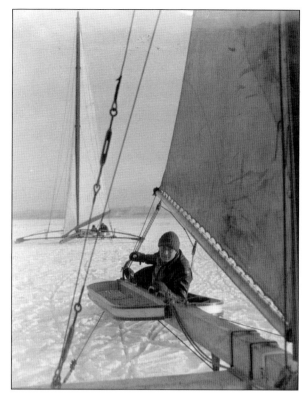

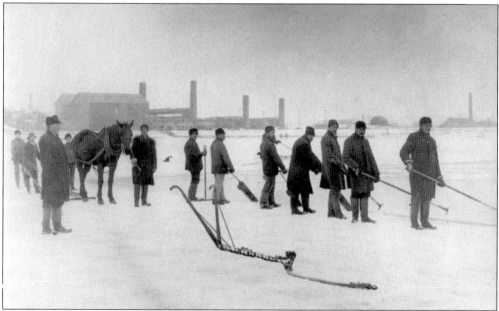

A group of workmen stop while cutting ice on the lake in the mid-1880s. The horse drew a tool that marked out blocks on the surface of the ice, while the men used saws to cut the ice and other tools to grab the blocks of ice. The icehouse and some boiling blocks are in the background. Commercial ice cutting was banned outright in 1901 due to severe lake pollution. (Courtesy of the Schuelke Collection, Liverpool Public Library.)

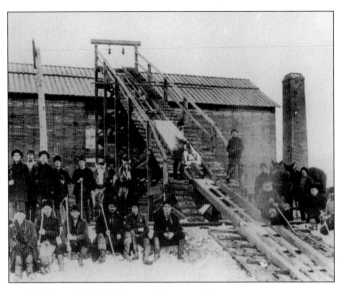

The New York State Board of Health expressed concern about the purity of ice cut from Onondaga Lake as early as 1887. Here, workers and their draft horses are posed in front of an icehouse. The conveyor belt carried the chunks of ice up into the icehouse where they were packed in sawdust to preserve them. This c. 1885 ice storehouse may have been located at the foot of Sycamore Street. (Courtesy of the Schuelke Collection, Liverpool Public Library.)

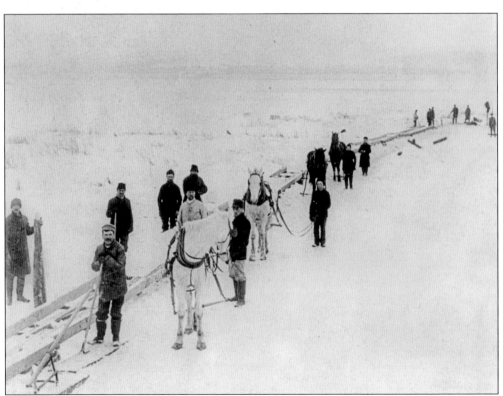

The workmen and their horses are about to go out on the lake ice. They are pictured near the side of a conveyor belt used to haul large blocks of ice from the edge of the lake to the icehouse. Many of these men worked in the salt blocks and solar salt yards during the summer months. They also might have woven baskets when they were not cutting ice. (Courtesy of the Schuelke Collection, Liverpool Public Library.)

Dan Dashley (1883–1967), shown here in his band uniform around 1899, was a natural entertainer and drum major who led award-winning bands around the country. He organized Dan's Boys Drum and Bugle Corps in Liverpool in 1926 with 48 boys and expanded the group to 115 in 1932. Rehearsals were held in his home. (Courtesy of Liverpool Village Museum.)

Dan's Boys Drum and Bugle Corps, a fixture in Liverpool parades and festivities, pose in Johnson Park. Dan Dashley, their leader, stands behind the boys with the bass drums. The 400 block of Tulip Street is in the background. From left to right are today's Maurer Funeral Home; a house that has been converted to apartments and Liverpool Chiropractic & Wellness office; and the Café at 407. (Courtesy of Liverpool Village Museum.)

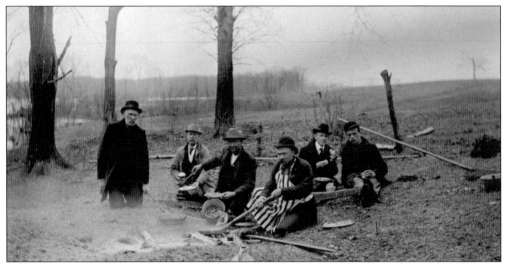

Published in the 1930 *Liverpool Centennial* book as "Shore Dinner," the ingredients of the dinner seem to be a jug, good friends, and perhaps frogs' legs on a skewer. As the Oswego Canal fell into disuse, Liverpool boys made some cash by whacking frogs near the canal with repurposed barrel staves and selling the victims to local restaurants and picnickers like these. (Courtesy of the Schuelke Collection, Liverpool Public Library.)

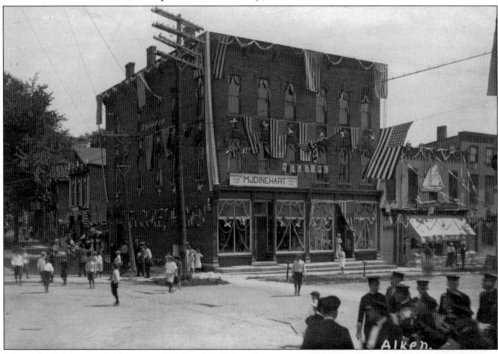

These buildings at the corner of First and Tulip Streets are decorated for the Onondaga County Volunteer Fireman's Convention, around 1905. From left to right on First Street, the businesses include Martin Dinehart's Grocery, Flour and Feed store on the corner, May E. Allen's Fabric and Dry Goods Store at 324 First Street, and Ziegler's Bakery. The fireman's convention brought welcome commerce to village businesses. (Courtesy of the Crawford Collection, Liverpool Public Library.)

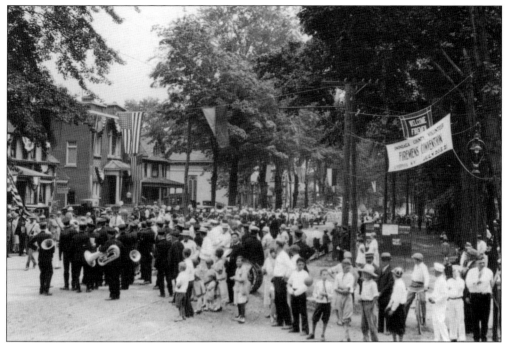

The Onondaga County Volunteer Firemen's Convention was held in Liverpool on July 20 and 21, 1927, amid much fanfare. This crowd at the intersection of Oswego and Tulip Streets has gathered to watch the parade. The buildings are, from left to right, Maurer's Store, the Masonic temple, the Methodist Church parsonage, and the First United Methodist Church. (Courtesy of the Schuelke Collection, Liverpool Public Library.)

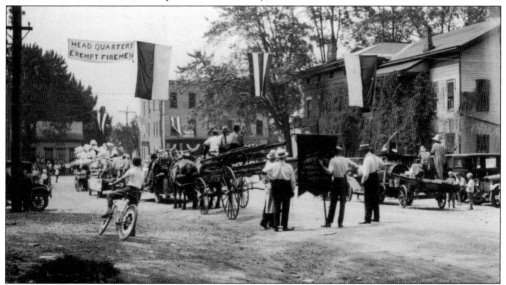

The 1927 Onondaga County Volunteer Firemen's Convention parade proceeds down Tulip Street toward First Street. A decorated truck carrying the Liverpool Fire Department's Ladies Auxiliary heads a group of motor and horse-drawn vehicles. The vine-covered Cobblestone Hotel is on the right, and the Hand Building is visible at the end of the street. (Courtesy of the Schuelke Collection, Liverpool Public Library.)

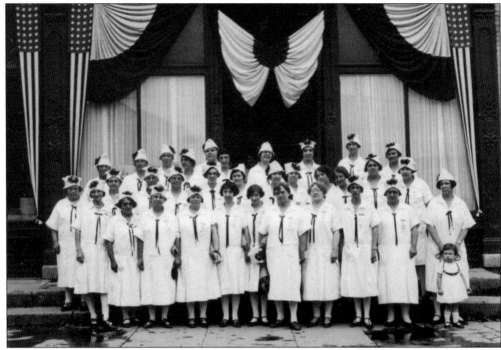

The Ladies Auxiliary of the Liverpool Fire Department pose in front of the Hand Building at 401 First Street to celebrate the Onondaga County Volunteer Fireman's Convention in 1927. Like much of the village, the storefront is decorated with bunting and flags. (Courtesy of the Schuelke Collection, Liverpool Public Library.)

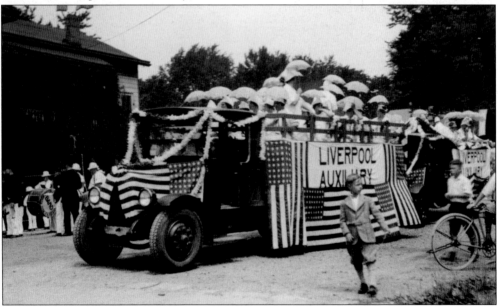

On July 21, 1927, a well-dressed young lad walks past the lavishly decorated truck carrying the Liverpool Fire Department Auxiliary. The parade is stopped, the ladies have put up their shade umbrellas, and a band is waiting next to the Cobblestone Hotel. (Courtesy of the Schuelke Collection, Liverpool Public Library.)

Liverpool's first community Christmas tree was mounted on a bandstand in Johnson Park in 1929. The tree was the beginning of a tradition that still continues today. Currently, the celebration features Christmas carols by the Liverpool Community Chorus and a visit from Santa, who rides in on a fire truck. (Courtesy of the Schuelke Collection, Liverpool Public Library.)

Arthur Hettler was Liverpool's well-loved Santa for about 15 years, from about 1936 to 1951. The good-natured 215-pound Kilian Manufacturing Company employee was well suited for this role. Hettler was a World War I veteran who was active in the American Legion and Veterans of Foreign Wars. Here, he thrills Liverpool children at the village's 1947 Christmas Eve festivities. (Courtesy of Liverpool Village Museum.)

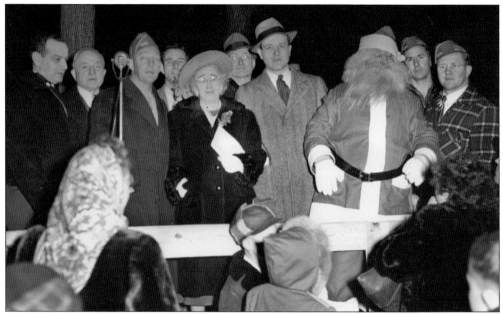

Arthur Hettler as Santa helps open the Christmas Eve festivities in 1949. Mayor Michael Heid is standing second from left. Heid (c. 1881–1968) served as Liverpool mayor from 1934 to 1951. Part of the Heid family of grocers and restaurateurs, Heid was himself a village institution. (Courtesy of Liverpool Village Museum.)

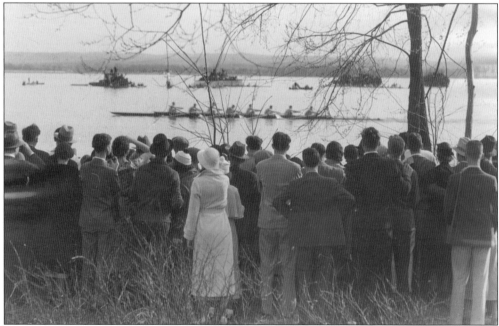

This crowd is watching an eight-man shell row by in what Liverpool photographer Theodore Schuelke called "Liverpool's first Collegiate Regatta." The photograph was taken in 1931. Syracuse University's crew had long used the lake for practice, and from 1952 to 1992 the Intercollegiate Rowing Association (IRA) held their races on Onondaga Lake. (Courtesy of the Schuelke Collection, Liverpool Public Library.)

Six

20th-Century Express

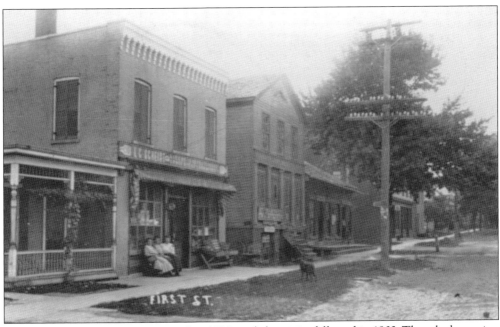

Telephone service came to Liverpool in 1900, and electricity followed in 1903. The telephone sign by the store doorway and the telephone pole with glass insulators date this First Street scene to that transition period, where, despite developing technology, the street is still dirt and a hitching post remains in the background. (Courtesy of the Crawford Collection, Liverpool Public Library.)

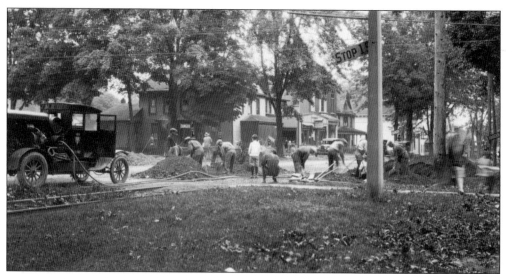

At the intersection of Tulip, Third, and Oswego Streets, a young boy watches men dig a ditch to hold gas lines, a utility new to Liverpool in 1928. Besides gas for heating and cooking, 1928 also brought public water service to the village, a service previously deemed "too expensive" by villagers who relied on outhouses, public and private wells, and cisterns to trap rainwater. (Courtesy of the Schuelke Collection, Liverpool Public Library.)

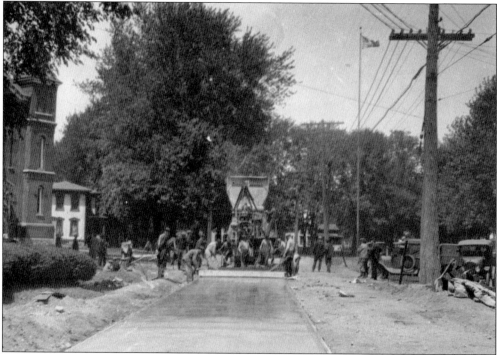

The age of the auto was also the age of pavement. Liverpool's dirt streets began to be paved in the 1920s. Here, a large group of men and machinery are working to pave Tulip Street just past the intersection with Oswego Street, near the entrance to the Liverpool First Presbyterian Church. Several period automobiles are also in this 1929 photograph. (Courtesy of the Schuelke Collection, Liverpool Public Library.)

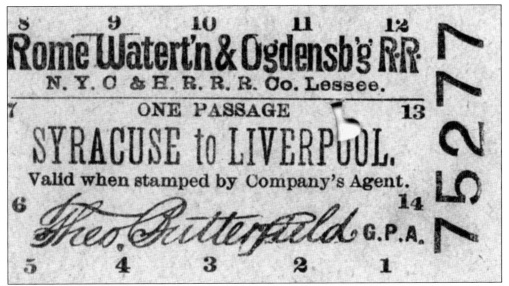

This railroad ticket is a record of a trip from Syracuse to Liverpool. The New York Central and Hudson River Railroads have leased the train tracks from the Rome, Watertown, & Ogdensburg Railroad; New York Central would eventually take over the entire route, but passenger service would cease in 1964. (Courtesy of Liverpool Village Museum.)

The stamp on the back of the ticket reads, "October 6, 1894." The advent of commuter trains and trolleys between Liverpool and Syracuse opened up industrial and clerical employment opportunities not readily available in earlier times. However, as the age of the automobile progressed, the trains outlived their usefulness. (Courtesy of Liverpool Village Museum.)

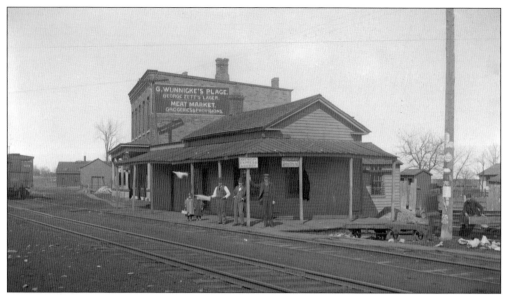

The first Syracuse Northern train steamed through Liverpool in 1871. By 1892, a small train station hugged the tracks; standing on the platform are two men, two children, and a conductor. The building next to the station was Wunnicke's Place. Murphy's Trackside tavern was the last occupant of that building, which was torn down in 1997. (Courtesy of the Crawford Collection, Liverpool Public Library.)

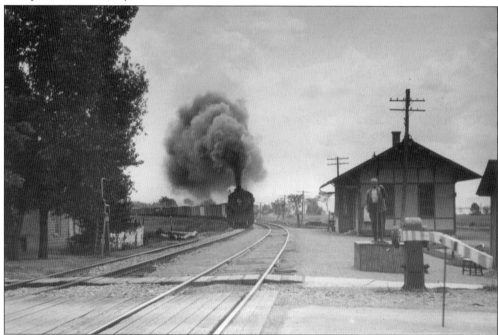

Liverpool's second railroad station, on the south side of Old Liverpool Road, is pictured on August 4, 1924. The man standing on the platform is holding the control to the crossing gate. A locomotive with a trailing plume of dark smoke steams through the station. The pole on the left is meant to hold mailbags for "flying pickup" from the train. (Courtesy of the Schuelke Collection, Liverpool Public Library.)

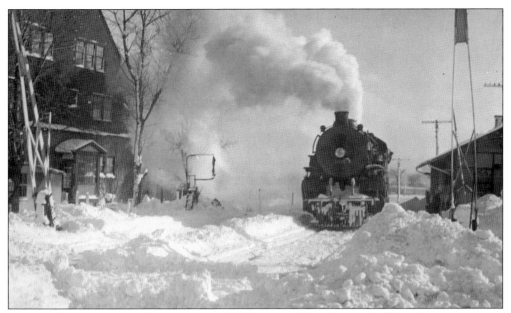

At the railroad station on the south side of Old Liverpool Road, around 1932, a bag is in position for pickup on the flying pickup pole. The large building on the left is Heid's Restaurant located on Old Liverpool Road. It burned in 1971. (Courtesy of the Schuelke Collection, Liverpool Public Library.)

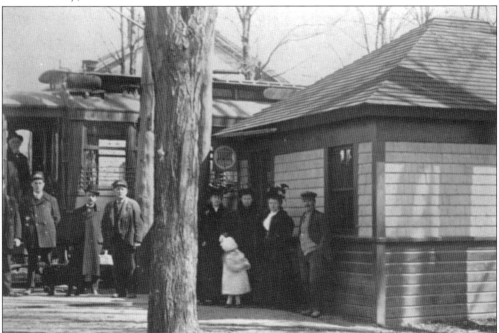

The 20th century clattered into Liverpool with the first trolley in 1903. On Sunday, March 1, 1903, Frank S. Gleason of 314 First Street wrote in his diary, "Hurray! Our Trolly line is complete & cars are running between here and Syracuse. First car came from the city yesterday at 4:30 PM. As the car was coming up by the Park the church bells began to ring . . . Everybody satisfied & Jubilation is rampant." (Courtesy of the Crawford Collection, Liverpool Public Library.)

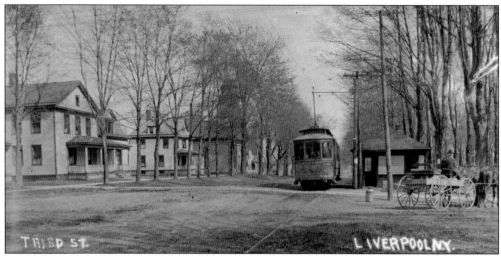

This postcard shows the trolley at the station on the Oswego Street edge of Johnson Park near the intersection with Tulip Street. A man turns his head to look at the trolley from his "old-fashioned" horse-drawn wagon. The trolley opened a more convenient way to better jobs and commerce in downtown Syracuse, and perhaps signaled the beginning of the end of the village way of life, where most people made their living where they resided. (Courtesy of Liverpool Village Museum.)

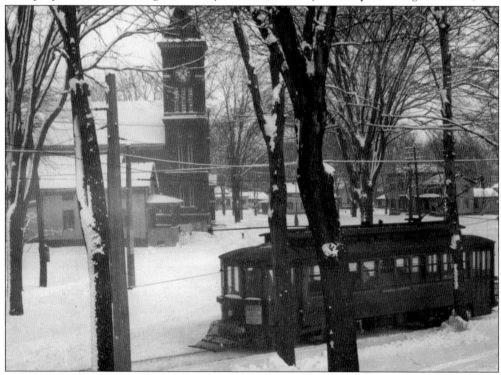

When trolley service was extended to Liverpool village in 1903, the tracks stopped at Johnson Park. Later, they were extended up Third Street to Hickory Street, where there was a turn-around that would later be used by public bus service. This trolley is heading up Third Street past the Presbyterian Church on a snowy January 24, 1922. (Courtesy of the Schuelke Collection, Liverpool Public Library.)

Dr. Charles G. Schamu (1875–1959) and his wife, Gertrude R. (1882–1972), pose outside their house at 200 Third Street. Dr. Schamu, a lifelong resident of Liverpool, practiced dentistry in the village for over 50 years and served as mayor of the village for one term in 1926. (Courtesy of the Schuelke Collection, Liverpool Public Library.)

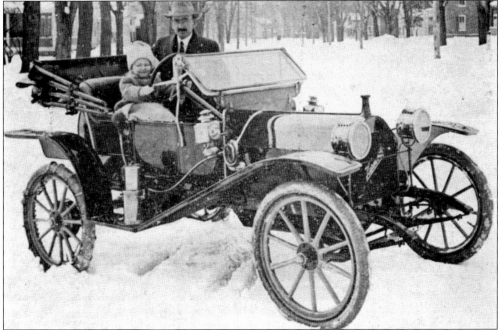

The forward-thinking Dr. Schamu owned the first automobile in Liverpool. He is shown here with his son Carl (1909–2002) in his new Hupmobile, around 1912. Dr. Schamu's sons were Carl, David, and Frederick. Carl and David also became dentists. (Courtesy of Liverpool Village Museum.)

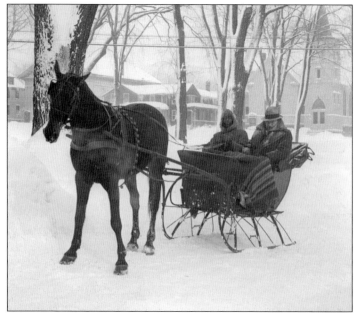

Family doctors used to make house calls. Dr. Herman Harding (d. 1954) heads off to make his house calls on Cold Springs Road on a snowy day in February 1936. Albert Fuller's horse and cutter can negotiate the road too snowbound for cars. Seen in the background at the right is St. Paul's Lutheran Church on the corner of Oswego and Vine Streets. (Courtesy of the Schuelke Collection, Liverpool Public Library.)

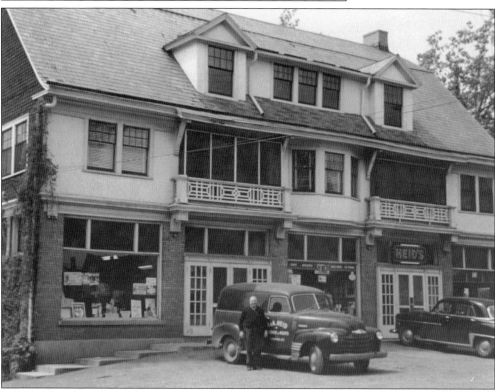

Michael Heid Sr. (1850–1927) moved to Liverpool in 1886 and opened a meat market on the corner of Vine and Oswego Streets. The business next moved to the railroad station in 1887 and then to a building on Old Liverpool Road in 1889 that was destroyed by fire in 1911 but reopened in 1913. In the early 1950s, Valentine Heid poses with his delivery van. This is the new store that opened in 1913. (Courtesy of the Crawford Collection, Liverpool Public Library.)

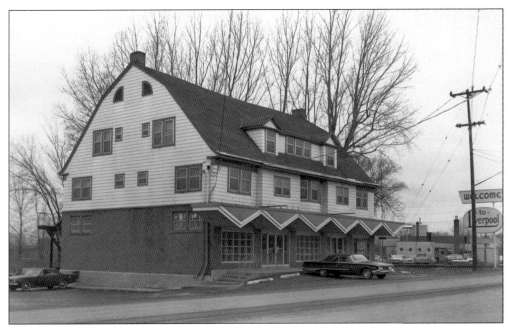

A meat market and grocery store were on the left, and the restaurant was on the right. The second floor provided living and office quarters; the third floor was a meeting hall used for dances, banquets, and meetings. The grocery store still delivered groceries into the 1950s and the restaurant remained in operation until Valentine Heid died in 1959. After his death, the restaurant closed for good, and the building burned in 1971. (Courtesy Joyce M. Mills.)

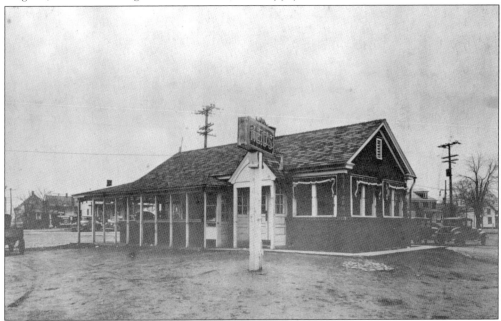

Valentine Heid (1888–1959) opened a new hot dog stand in 1931 on the corner where it still stands today. It was popular from the start but really took off when the new Onondaga Lake Parkway opened in 1933. It would become an icon that identified the village of Liverpool to residents and travelers. (Courtesy of Liverpool Village Museum.)

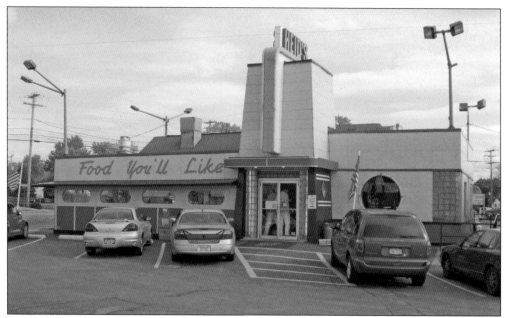

The familiar Streamline Moderne exterior materials added to the hot dog stand were purchased at the 1939 New York World's Fair. The hot dog stand was the last of the Heid family's business ventures in Liverpool and left the family's hands in August 1995. However, it remains a Liverpool tradition, and during good weather, lines still form out to the street. (Photograph by Joyce M. Mills.)

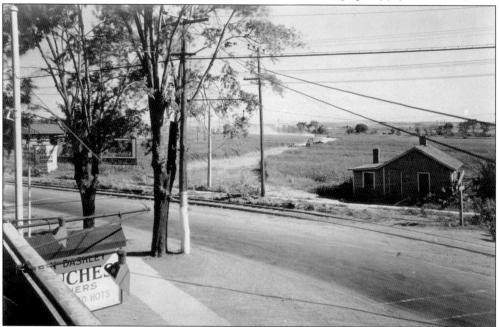

The date is July 29, 1930. Construction of Onondaga Lake Parkway has just begun. Taken from the roof of Dan Dashley's diner and looking southwest across Oswego Street, this photograph shows the railroad station behind the Socony service station sign. The familiar landmarks of Heid's hot dog stand and Onondaga Parkway itself are still in the near future. (Courtesy of the Schuelke Collection, Liverpool Public Library.)

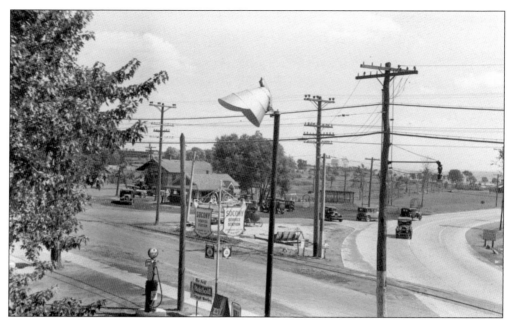

The year is about 1933. The same view looking southwest now shows the completed, paved Onondaga Lake Parkway. At the left in front of the railway station, Heid's hot dog stand has been constructed. The bowling alley has not yet been built to the right of the hot dog stand, and the stand itself will not receive its familiar Art Deco look until 1939. (Courtesy of the Schuelke Collection, Liverpool Public Library.)

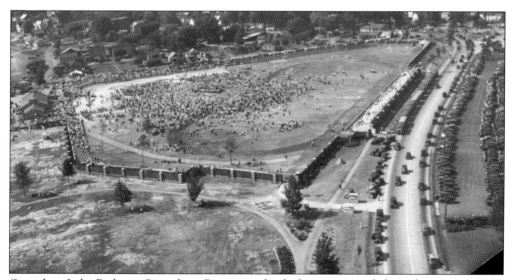

Onondaga Lake Park, an Onondaga County work-relief project, was dedicated in August 1933. The parkway was not envisioned as a commuter highway but instead as a place for leisurely Sunday drive. This aerial view shows Griffin Field on the day of the dedication. Today, Griffin Field is gone, and only the stone pillars remain of the wall that once surrounded the field. (Courtesy of the Schuelke Collection, Liverpool Public Library.)

Families visit the partially completed "French Fort" in the summer of 1933. Onondaga Lake Park was one of Onondaga County's innovative public works projects, launched in the depths of the Great Depression to employ county residents and provide recreation opportunities for generations to come. Often mislabeled as a WPA project of the federal government, the county project preceded that program and served as a model for it. (Courtesy of the Schuelke Collection, Liverpool Public Library.)

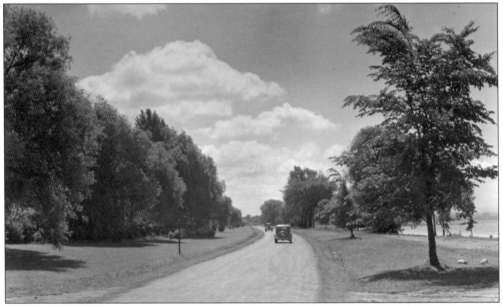

The old Oswego Canal bed was filled in as part of Onondaga County's work-relief project in the early 1930s. This section was reopened as Lakeshore Boulevard. In 1939, people could drive along the lakeshore. Today, the road is closed to automobile traffic but is used by some four million bicyclists, skaters, and walkers a year. (Courtesy of the Schuelke Collection, Liverpool Public Library.)

A man holds a Holstein-Friesian cow in front of one of the Stevens Brothers-Hastings Company barns in Liverpool. The Stevens Brothers sold championship cattle in their auction house on Old Liverpool Road to international buyers. Their barns, however, were located on Vine Street just outside the village on land that would later be occupied by General Electric and is now an industrial park. (Courtesy of the Schuelke Collection, Liverpool Public Library.)

During the early 1900s, several large Holstein herds were established in and around Liverpool. The Stevens Brothers' Brookside Herd, considered to be one of the oldest and finest Holstein herds in the United States, arrived in 1904 from Lacona, New York, to farmland purchased on Vine Street. This advertisement appeared in the January 14, 1914, edition of the *Syracuse Herald Journal*. (Courtesy Joyce M. Mills.)

IF YOU NEED

Holstein Cows

Heifers, Calves

or Bulls

OF ANY AGE WRITE

Stevens Brothers Co.

LIVERPOOL, N. Y.

They Have the Goods and Their Prices
Are Reasonable for the Quality

THE BROOKSIDE HERD
350 HEAD
Established 1876

17 two yrs. old with 1st calf, 2 three yrs. old and 6 mature cows average 17003 lbs. milk, 783.7 lbs. butter in one year; Semi-official. Our animals have size, type, quality and capacity.

Stevens Brothers Co.
LIVERPOOL, N. Y.

THE SIRE OF WORLDS RECORD HEIFERS

HE HAS NO MATCH

By 1913, the Stevens Brothers had built a large Sale Pavilion on Old Liverpool Road to host its world-class cattle sales. Many industry records were set there for number of cattle offered and average prices paid per cow. Representatives from as far away as Japan once came to Liverpool to buy Holstein-Friesian cattle. This match case advertises "King of the Pontiacs," a prizewinning sire in the herd. (Courtesy of Liverpool Village Museum.)

Dwight R. Smith (c. 1896–1991) drives three horses pulling a grain binder on a beautiful late-summer day in 1930. Smith worked for Peter Krog (c. 1886–1958), who managed the Stevens Brothers cattle farm on Vine Street. Smith also worked as a bank teller and ran a farm stall at the Regional Market for over 70 years. (Courtesy of the Schuelke Collection, Liverpool Public Library.)

Pictured is Harvey A. Moyer (1853–1935). This formal portrait was taken around 1880, about the time he relocated his successful carriage factory to Wolf Street, Syracuse. In 1909, his son-in-law Ward Wellington Ward designed a new factory for the H.A. Moyer Automobile Company where beautiful luxury automobiles were produced from 1908 to 1915. Moyer was also a "gentleman farmer" whose farm on Old Liverpool Road was a showplace. (Courtesy Gary Smith, Moyer Historian.)

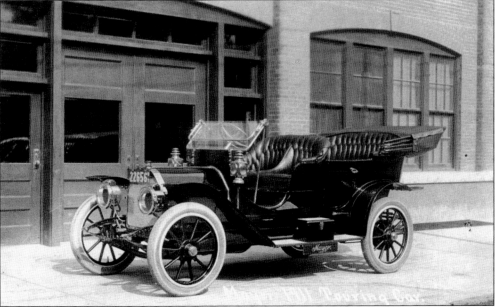

A 1911 Moyer touring car is parked in front of the H.A. Moyer Automobile Company, located on Wolf Street in Syracuse, New York. Moyer automobiles were relatively expensive because they were built in the same manner as Moyer's fine carriages—one at a time. They could not compete with Henry Ford's Model T, made with assembly line production methods. (Courtesy Gary Smith, Moyer Historian.)

Moyerdale on Old Liverpool Road was Harvey A. Moyer's summer home, but in 1915 the main house, remodeled by his famous son-in-law Ward Wellington Ward, became his permanent home. Moyerdale was best known for its prizewinning Holstein herd, but Moyer also owned fine racehorses. Moyer's home, on the left, was occupied by a descendant until July 1961. It was torn down in 1966 to make way for a car dealership. (Courtesy Gary Smith, Moyer Historian.)

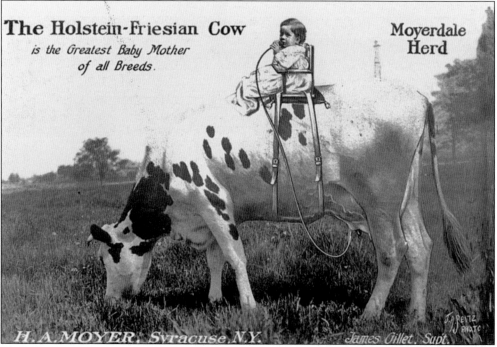

Moyer began advertising Moyerdale's dairy products in December 1917. He claimed that the milk was healthier—produced under clean circumstances and tested for tuberculosis—"clean milk from clean cows." He recommended that mothers whose babies were not thriving should switch to milk from Moyerdale. Throughout his adult life Moyer was a prominent businessman and politician, with many patents to his name. (Courtesy Gary Smith, Moyer Historian.)

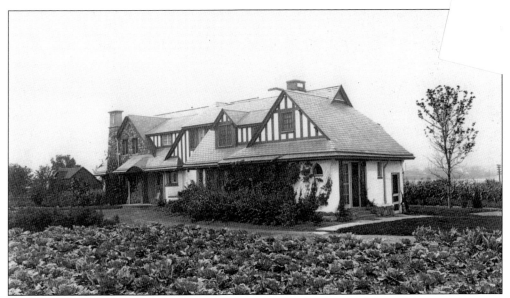

Famous Arts-and-Crafts architect Ward Wellington Ward's home, LeMoyne Manor, is shown in this c. 1916 photograph. Ward suffered an injury in 1926 that ended his career and led to his death in 1932 at age 57. LeMoyne Manor, located at 629 Old Liverpool Road, has retained its name but was incorporated into a restaurant-motel complex. The facade of the house is now barely visible. (Courtesy of the Schuelke Collection, Liverpool Public Library.)

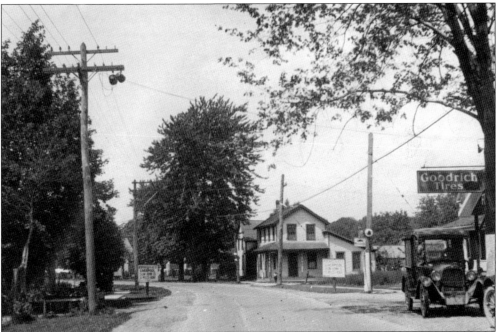

Old Liverpool Road curves around toward Liverpool village in 1930. The neighborhood still had several houses when this photograph was taken. The railroad crossing is just past the curve in this photograph, as it is today. The signs along both sides of the road read as follows: "Incorporated Village of Liverpool Slow down to 20 miles per hour." (Courtesy of the Schuelke Collection, Liverpool Public Library.)

Rosalind Brandt (left) and Mildred Davey, 14-year-old friends, pose in their Red Cross volunteer uniforms with their knitted "comfort cloth" afghan in 1917. The afghan would be sent to the troops serving overseas in World War I, via the Red Cross headquarters in New York City. The afghan was made up of 48 knitted blocks with a knitted and embroidered American flag in the center. The girls made the afghan with yarn and money donations from Liverpool villagers. (Courtesy of Liverpool Village Museum.)

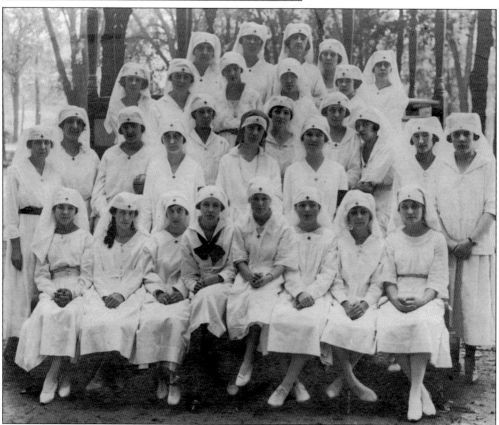

The Liverpool home front in World War I included these 30 Red Cross volunteers posing in Johnson Park. These young women could not immediately care for the soldiers, but they knitted afghans, socks, and mittens to send overseas. The German heritage of many Liverpool residents led to a newspaper article published around 1917 that was headlined: "Once German, Now Real American, It Has Sent 130 of Its Sons to War." (Courtesy of Liverpool Village Museum.)

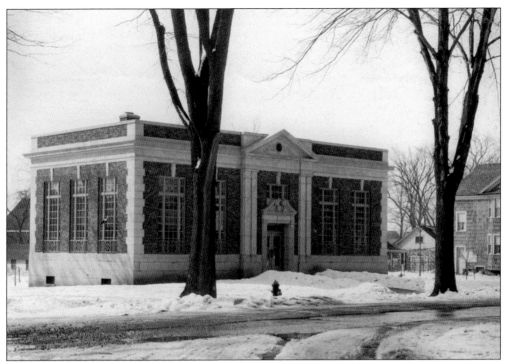

The Liverpool Bank was founded on June 23, 1928, the board of directors consisting mostly of Village residents. It started with $50,000 capital and $25,000 "surplus," and was turning a profit by 1929. In 1929, the bank bought and razed the 1830 Westgate-Corbin house at the corner of Second and Tulip Streets to build a new bank. It opened in 1930 and succeeded in spite of the Great Depression. Today, the building houses Key Bank. (Courtesy of the Schuelke Collection, Liverpool Public Library.)

During the Great Depression, the Liverpool Bank on Second Street issued scrip. Sponsored by the Business Men's Association, the goal was to spur business with local merchants. Beginning February 2, 1933, merchants bought scrip, and gave it out as change. The scrip could then be used to make new purchases. Called back in December 1933, only $100 was redeemed. The rest presumably went into collectors' hands and at least some to the Smithsonian Museum. (Courtesy of Liverpool Village Museum.)

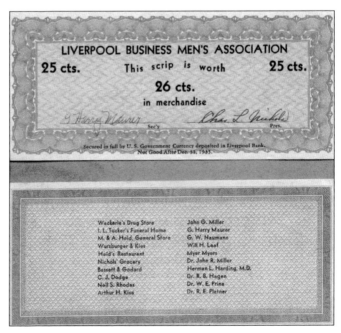

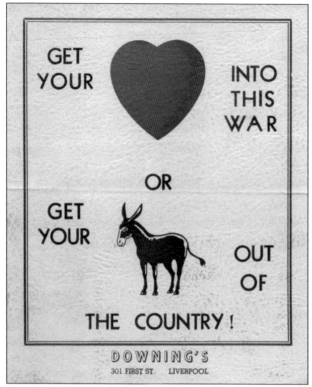

Downing's was one of a series of restaurant-taverns located at 301 First Street over the years. As in World War I, World War II brought rumors about the many Liverpool citizens of German descent—that there were Nazi sympathizers, or even a German-American Volksbund, a pro-Nazi organization during the 1930s and 1940s. Liverpool businessmen countered with advertisements such as these. (Courtesy of Liverpool Village Museum.)

The World War II Honor Roll, sponsored by the Liverpool Village Board and erected in Johnson Park, was dedicated in November 1942. The parents and relatives of some 130 enlistees from Liverpool and vicinity were present at the dedication. Names continued to be added as more and more citizens went to war. The monument was not intended to be permanent and was removed in 1949. (Courtesy of Liverpool Village Museum.)

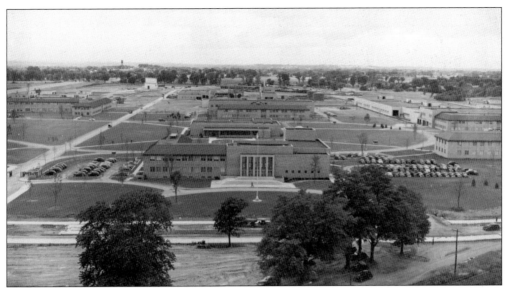

When the Soviet Union launched Sputnik into space in 1957, Cold War paranoia burgeoned. Fallout shelter plans were handed out in local schools, and "duck and cover" drills interrupted classes. It was said that the General Electric facility at Electronics Park was built to look like a college campus so that the defense contractor would be a less attractive bomb target. (Courtesy of Liverpool Village Museum.)

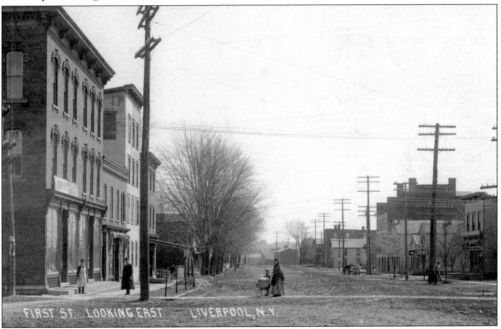

A woman and child cross First Street in 1905, near the intersection of the 19th and 20th centuries. Although the woman's long skirt brushes a dirt street, the telephone lines overhead signal a more modern age. The salt boilers, the canal, and the willow weavers are gone. Now, streets are paved and automobile traffic zips through the center of the village. But First Street remains, and despite almost two centuries' worth of change, village life continues. (Courtesy of Liverpool Village Museum.)

DISCOVER THOUSANDS OF LOCAL HISTORY BOOKS FEATURING MILLIONS OF VINTAGE IMAGES

Arcadia Publishing, the leading local history publisher in the United States, is committed to making history accessible and meaningful through publishing books that celebrate and preserve the heritage of America's people and places.

Find more books like this at
www.arcadiapublishing.com

Search for your hometown history, your old stomping grounds, and even your favorite sports team.

Consistent with our mission to preserve history on a local level, this book was printed in South Carolina on American-made paper and manufactured entirely in the United States. Products carrying the accredited Forest Stewardship Council (FSC) label are printed on 100 percent FSC-certified paper.

MADE IN THE